50 GEMS
DORSET

JOHN MEGORAN

AMBERLEY

Acknowledgements

The pictures of *Consul* and *Embassy* are courtesy of Pat Bushell. All other pictures are by the author. Background research has been aided by the Royal Commission's 1970 *Inventory of Historical Monuments in Dorset,* together with books by Maureen Attwool (nee Boddy), J. H. Bettey, Geoffrey Carter, Jo Draper, John Fowles, Robert Gittings, David A. Hinton, Brian Jackson, Stuart Morris, Andrew Norman, Nikolaus Pevsner, Eric Ricketts, Jack West and M. B. Weinstock.

First published 2017

Amberley Publishing
The Hill, Stroud
Gloucestershire, GL5 4EP

www.amberley-books.com

British Library Cataloguing in Publication Data.
A catalogue record for this book is available from the British Library.

ISBN 978 1 4456 7350 9 (paperback)
ISBN 978 1 4456 7351 6 (ebook)

Map illustration by User Design, Illustration and Typesetting.

Origination by Amberley Publishing.

Printed in Great Britain.

Contents

Map 4
Introduction 6

West Dorset 8
1 Lyme Regis and The Cobb 8
2 Belmont House,
 Lyme Regis 9
3 Forde Abbey 11
4 West Bay Harbour 12
5 Bridport 14
6 Abbotsbury 15
7 St Catherine's Chapel,
 Abbotsbury 17
8 Hardy's Monument 19

South Dorset 21
9 Chesil Beach 21
10 The Rodwell Trail 23
11 Church Ope Cove,
 Portland 24
12 Weymouth Promenade
 and Beach 26
13 Weymouth Harbour 29
14 Upwey 31
15 Ringstead Bay 32
16 Lulworth Cove 34
17 Lulworth Castle 36
18 Tyneham 38

Mid Dorset 40
19 Maiden Castle 40
20 Thomas Hardy's
 Cottage, Bockhampton 42
21 Dorchester 44
22 Dorset County Museum 46
23 The Keep Military
 Museum, Dorchester 47
24 Max Gate, Dorchester 48
25 Clouds Hill, near Moreton 50

26 St Nicholas Church,
 Moreton 52
27 Tolpuddle Martyrs,
 Tolpuddle 53
28 Wareham 55
29 Corfe Castle 57

East Dorset 59
30 Swanage 59
31 Swanage Railway 60
32 Durlston Country Park 62
33 East Dorset Coast 64
34 Poole Quay 66
35 Brownsea Island 67
36 Bournemouth 69
37 Russell-Cotes Art
 Gallery and Museum,
 Bournemouth 71
38 Bournemouth Pier 72
39 Pavilion Theatre
 Bournemouth 74
40 Tuckton Tea Garden
 Boats, Christchurch 76

North Dorset 78
41 Cerne Giant 78
42 Milton Abbas 79
43 Blandford Forum 81
44 Kingston Lacy 83
45 Sturminster Newton 85
46 Sherborne 87
47 Sherborne Castle 89
48 Fontmell Magna 90
49 Shaftesbury 92
50 Dorset Railways 94

About the Author 96

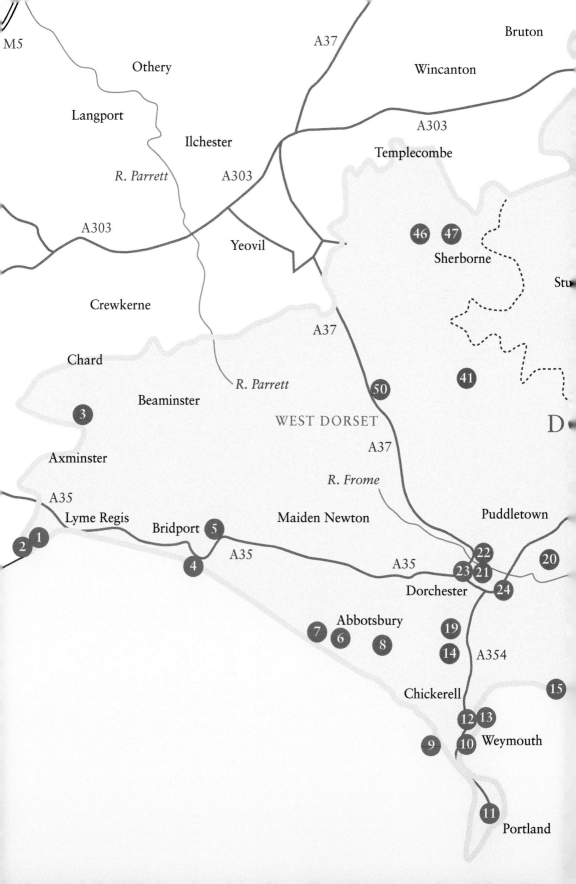

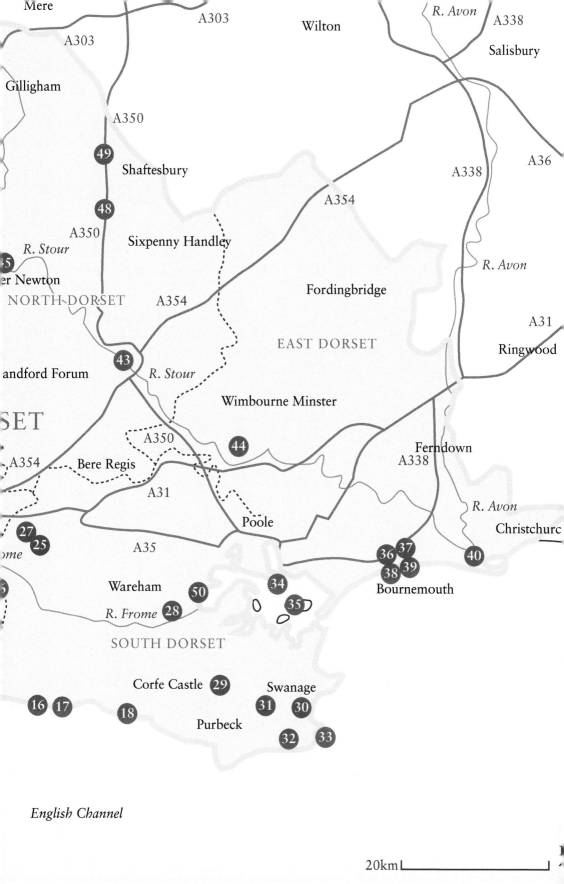

Mere

A303

A303

Gilligham

A350

49

Shaftesbury

48

A350

R. Stour

5

er Newton

NORTH DORSET

A354

andford Forum

43

R. Stour

SET

A354

Bere Regis

A350

A31

27

25

ome

A35

Wareham

50

R. Frome 28

SOUTH DORSET

Corfe Castle 29

16 17

18

Purbeck

English Channel

Wilton

R. Avon

A338

Salisbury

A36

A338

R. Avon

Fordingbridge

A31

EAST DORSET

Ringwood

Wimbourne Minster

Ferndown

A338

44

R. Avon

Poole

Christchurc

36 37

40

38 39

34

Bournemouth

35

Swanage

31 30

32 33

20km

Introduction

The eastern boundary of Dorset is little more than a hundred miles from London, yet as you move westwards through the county you feel that you are further away than from the metropolitan world. With the exception of the large urban conurbation extending from Poole through Bournemouth to Christchurch, Dorset's towns are small and largely unspoilt. As you drill down further into the hinterland of the countryside with its wealth of rolling hills, thatched cottages and tiny lanes you get a feeling that time has stood still here.

Could that be Gabriel Oak tending his sheep in the next field? Maybe that flash of scarlet in the distance is Sergeant Troy's tunic as he advances his military overtures towards the highly receptive Bathsheba Everdene in Thomas Hardy's *Far from the Madding Crowd*.

Dorset is not a large county but its scenery is varied. The chalk uplands of the north and the Blackmore Vale are quite different from the limestone rocks of Purbeck in the south-east. The water meadows along the banks of the meandering rivers Frome and Stour, awash with golden celandines in spring, have little in common with the curious pointy hills in the west, which look to me like monolithic grass-covered lampshades planted indiscriminately across the landscape. Look more closely at some Dorset hills and you will find that they are not hills at all but the remains of Neolithic forts.

Then there is the coast. And what a coast it is, with so many idiosyncratic features, the likes of which you will not find anywhere else. There is Portland, a mass of stone shaped like an enormous wedge of cheese, high in the north and diminishing to nothing at its southern tip, and attached to the mainland by the extraordinary Chesil Beach. Then there is Lulworth Cove, indented into the cliffs. And let's not forget Poole Harbour, a ria of profound enormity making it one of the world's largest natural harbours.

The marketing men have moved in here and rebranded this lovely part of Dorset in recent decades as the Jurassic Coast, doubtless in the hope that thoughts of dinosaurs and pterodactyls will make the cash registers ring faster in the tourist tills. Of course, it is a Jurassic coast, and all with a fondness for fossils will find much to amuse themselves here; but, for me, Jurassic is such an ugly word for such a beautiful place. Think instead of the mellifluous sweetness to the ear of the name by which it was always formerly known – the Dorset

Coast – or even better when spoken in the lovely lilt of a local lad from Swyre as the 'Darssett' Coast.

This book is not intended as a gazetteer. If you want to know the opening times, which bus to catch, or where to park your Lambretta then you will have to look elsewhere. Instead, what I have tried to do is to give a feel of the places in Dorset that I love and the people connected with them in the hopeful expectation that if I like something then there must be others among all of you out there who might like them too.

Anyway, enough of introductions. Let's dive in, and what better place to start than the lovely seaside town of Lyme Regis on Dorset's western border with Devon.

West Dorset

1 Lyme Regis and The Cobb

Lyme Regis is in three parts. There is the steep hill with all the small shops 'almost hurrying into the water below' as Jane Austen put it. You will find the Royal Lion Hotel here familiar to all who have seen the film *The French Lieutenant's Woman.*

 Then there is the Marine Parade extending west about half a mile along the edge of the beach with its quaint Madeira cottages. So charming and evocative of another age are they that you half expect a boy bowling a Victorian hoop to emerge from one or perhaps a Betsy Trotwood with stick in hand agitated as ever and berating noisy visitors encroaching on the peace and quiet of her sunny seaside retreat.

Madeira Cottages and Marine Parade, Lyme Regis.

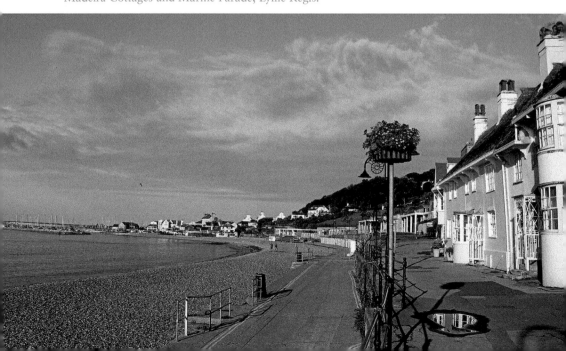

The Cobb, Lyme Regis.

At the end of that is the Cobb surrounding the little harbour and keeping out the storms and hurly burley sweeping up the Channel in darkest winter. Although once an important port, today the harbour is filled mostly with private craft and a collection of small fishing and angling boats, some of which take visitors for trips around the bay or out to sea to haul up a line or two of freshly caught mackerel.

Please keep this to yourselves (and don't whatever you do pass it on to anyone you know who has a fondness for donning yellow high-visibility vests, hard hats and clipboards loaded with risk assessments) but for me one of the great charms of the Cobb is that it remains much as it was when built in its final form in the early nineteenth century. It is a stone jetty of uneven surface with a collection of warehouses and stores, one of which now contains an aquarium, with a higher level reached by 'Granny's Teeth' steps. No handrails here – and all the better for that. If you think that you might fall off don't go up.

It was on the top of the Cobb that Meryl Streep stood, as the French lieutenant's woman, looking out to sea, contemplating her troubled past and imagining her uncertain future.

2 Belmont House, Lyme Regis

Belmont House is one of those buildings that acquire gem status through the accumulation of multiple layers of interest down through the generations.

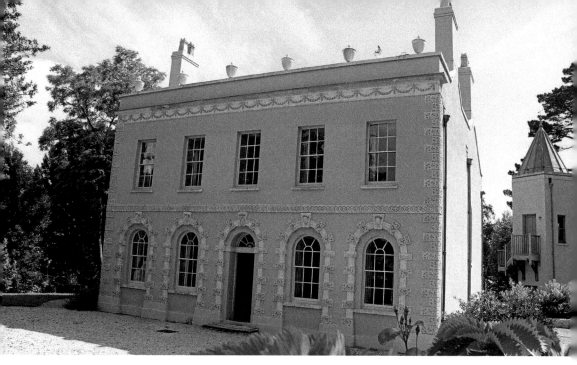

Belmont House in Lyme Regis with Coade stone decorations.

Originally built as Bunter's Castle for lawyer Simon Bunter in 1774, it was one of the many substantial properties developed in pleasant seaside locations in the late eighteenth and early nineteenth centuries on the back of the then mania for sea air and seawater bathing as health cures among aristocrats and the gentry were increasingly sought.

A decade later the house passed to Eleanor Coade, who ran a successful business in London producing an artificial stone particularly suitable for ornaments on and inside buildings. There are examples of her work all over the place including at Buckingham Palace, the Brighton Pavilion and in Weymouth as the Coade stone was used to construct George III's statue.

Eleanor rebuilt the property substantially, renamed it Belmont House and adorned both the outside and inside with all manner of Coade stone decorations including friezes, keystones portraying Neptune and Amphitrite and wonderful fireplace surrounds. You might say that it was a sort of Coade stone showhouse.

During the nineteenth century there were various tenants until the property was bought in 1883 by Dr Richard Bangay, who was a keen geologist, botanist and astronomer. He extended the house as well as putting up a tower on the side with a roof with winding gear so that it could be opened to give a better view of the stars for his telescope.

If all that is not enough for any one house, in 1968 it was bought by author John Fowles, whose works include the *The French Lieutenant's Woman*, *The Collector* and *The Magus*. He lived there until his death in 2005, writing all his later works in a room overlooking the sea. Although, like many writers, he was somewhat reclusive, Fowles took a great interest in the town and was curator of the Lyme Regis museum for a decade.

Today, Belmont House is owned by the Landmark Trust and is open to the public from time to time. It is also in their portfolio of holiday lets giving all the opportunity to stay in a house steeped in so much history, and absorb the ambiance and views enjoyed by the previous tenants. Could you start writing your own novel sitting in John Fowles's study looking out to sea over a long weekend break?

3 Forde Abbey

Forde Abbey spans nearly a thousand years of history and is a good testament to how buildings change and evolve according to the political upheavals and the differing views and tastes of their owners as the centuries unfold.

It all started in 1141 when a group of Cistercian monks set up a monastery on the site. This expanded and thrived for over 400 years until Henry VIII dissolved the monasteries, with Forde Abbey being seized by the Crown.

After a century of neglect the abbey was bought by Edmund Prideaux, MP for Lyme Regis and Attorney General for Cromwell, in 1649, who expanded the building as his private home. His son, also called Edmund, made the serious error of entertaining the Duke of Monmouth in 1680 five years before he landed with his invasion force at Lyme Regis, which almost cost him his life and his fortune.

Forde Abbey Porch and Great Hall.

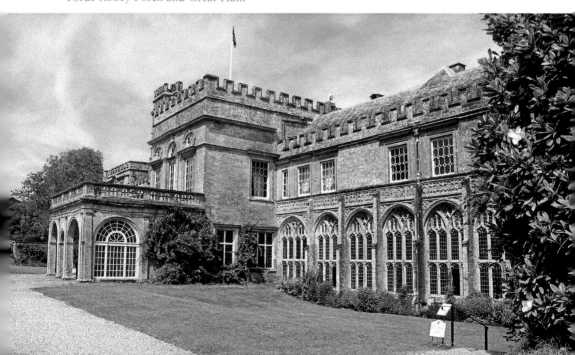

Part of Forde Abbey's extensive gardens.

His daughter married Francis Gwyn, Secretary of War for Queen Anne, and they started to create the fabulous gardens surrounding the house. Their descendants fell on hard times so in the early nineteenth century the abbey was let to the philosopher Jeremy Bentham, who brought his thinking friends and associates to stay including John Stuart Mill and reformer Sir Samuel Romilly.

The abbey was put up for sale together with its contents in 1846 and was initially bought by a rich merchant before finally passing to the Roper family in 1905, who still own the estate today.

It is a wonderful house. You will probably have seen it on the big screen and on the television as it is a popular film location. Outside the gardens are among the best in Dorset.

4 West Bay Harbour

I first visited West Bay Harbour as a boy with my father in the early 1960s. It was a stormy day and waves were crashing over the two breakwaters sticking out into the sea. I looked at the narrow entrance with the huge seas piling on through the narrow gap and wondered how any ship or boat ever got in or out.

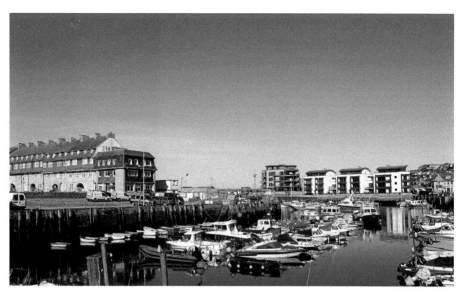

West Bay with the 1885 Arts and Crafts buildings designed by E. S. Prior.

An unusually flat, calm day at West Bay.

We had gone to see the last trading schooner *Result* and there she was safely moored inside so it was possible but, my goodness, clearly you needed fine weather to do it.

West Bay is not a natural harbour. Although some sort of haven had been built by the fourteenth century, it was not until the late eighteenth and early nineteenth centuries that the larger basin we see today was constructed in its present form.

In its heyday, West Bay was busy and photographs from the late Victorian era show it stuffed full of sailing ships and other craft. Coasters continued to visit from time to time until the 1960s but today the harbour is a place for leisure rather than commerce with many small privately owned craft on their moorings and others launched at weekends for an afternoon afloat from the slipway.

The harbour was part of the setting for the popular television series *Broadchurch*, so if you are a fan you can try spotting the newsagent, fish shop, caravan park and the cliffs on each side where the dastardly deeds occurred.

Alternatively, you can hire a rowing boat on the River Brit above the harbour sluice just as Dad and I did all those years ago with a friend of the family, Mr Allen. He had been a newspaper editor on Jersey before fleeing the Nazi invasion in the Second World War in which he lost everything. By then in his eighties, he was eking out an impoverished retirement living in a sort of converted caravan not unlike those featured half a century later, and containing a different sort of character, in Broadchurch.

5 Bridport

Bridport has to me the feel of having a hinterland increasingly colonised by the metropolitan liberal elite at play. Of course, that is not all that it is.

There is the literary festival, the art exhibitions, the cinema showing the less mainstream films, the poetry readings, craft fairs, a talk on Walt Whitman, a folk festival and so on. You won't find any of that, on a regular basis anyway, in Weymouth. You will find it here in Bridport in spades.

There are three main streets meeting at a 'T' junction by the marketplace where the Town Hall, dating from 1786 with its clock and cupola, is unmissable. I spent a happy hour there last summer being cheered up by a crimson-clad brass band pumping out their rhythmic merriment.

The aptly named East, West and South Streets fan out with a good range of Georgian façades. There are sometimes market stalls selling everything from fresh vegetables through clothing and drapes to antiques, books and collectables. There is even a hat shop – how often do you come across those these days? – offering extravagant headpieces for weddings and social events for the ladies and the sort of sartorial extras that any gentleman should never be without. Have you tried the maroon waistcoat with the gold stars?

I like Bridport. I go there often, although I rarely stay very long. I find a little walk up and down the gently sloping streets, a coffee and a bun, a browse in Waterstones, a purchase of some quality home-made bread and sticks of rhubarb uplifting.

I then return home cheered up with the comforting thought that, if I want, I can go back again next week and hear Jeremy Paxman, or some other

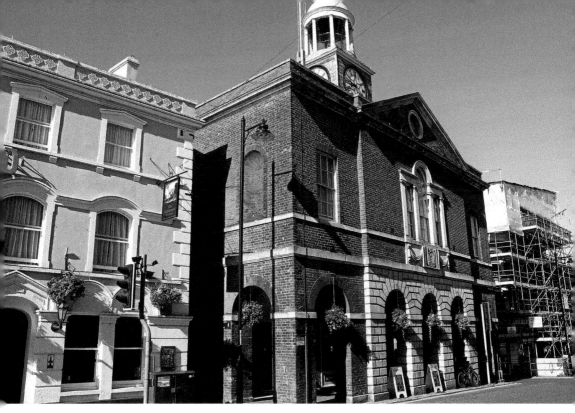

Bridport Town Hall.

distinguished speaker, expound on the vital issues of the day; or if not next week then the week after that or perhaps even the week after that too.

6 Abbotsbury

A Benedictine monastery was founded at Abbotsbury in the eleventh century by Orc, steward to King Cnut, and seems to have thrived in its early days acquiring a Tithe Barn around 1400, which, at 272 feet in length, is one of the largest of its kind anywhere in England. Sadly, that is the only substantial part of the monastery to have survived, the rest having been smashed up and looted in Henry VIII's Dissolution of the Monasteries in 1439.

The chief beneficiary of this was Giles Strangways, who acquired the land and much of the wealth of the monastery for his own estate. This has passed down through successive generations to the Ilchester family, which still owns the freehold of much of Abbotsbury today.

The village is attractive with its stone cottages under thatched roofs with high pavements in places served by steps that stick out into the roadway. There are no street lights, which for a 30-mph speed limit area is very rare anywhere. If it were

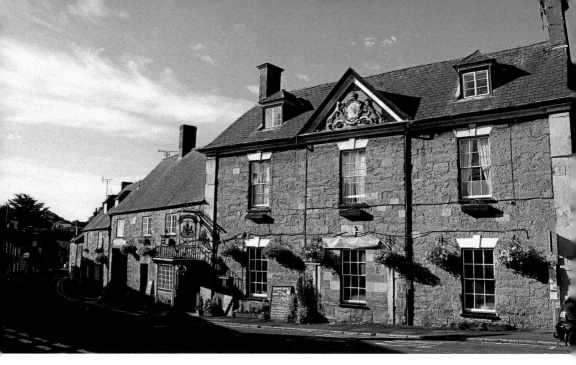

Above: The Ilchester Arms, Abbotsbury.

Below: The Swannery at Abbotsbury.

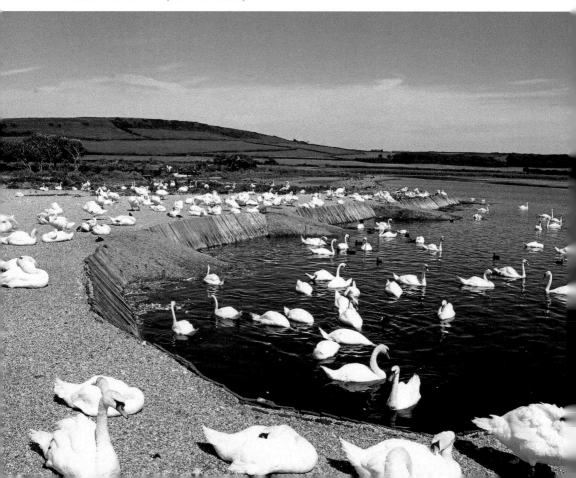

not for the traffic trundling through between Weymouth and Bridport, you could stand in the centre between the Victorian Gothic schoolhouse and the eighteenth-century Ilchester Arms and imagine that you were a hundred years back in time.

There is less traffic to the south of the village where the Tithe Barn stands, now open as a children's farm. A short walk further on takes you to the swannery where hundreds of swans put down each spring to make their ramshackle nests out of any old bits of twig and other odds and ends to lay their eggs and bring up their young cygnets.

There has been a swannery at Abbotsbury since at least the fourteenth century when it was an adjunct to the monastery to provide swans for the table. Eating them today is banned, although the monarch and the Fellows of St John's College, Cambridge, allegedly still retain the right to tuck in under ancient statute if desired. The latter is wonderfully satirised in Tom Sharpe's witty 1974 novel *Porterhouse Blue* in which a grand feast is staged, including roast swan stuffed with widgeon, for the new Master of College, who turns out to be a vegetarian.

7 St Catherine's Chapel, Abbotsbury

There can be few people who have passed through Abbotsbury and not wondered to themselves why this chapel was erected in such an odd place, right on the top of a hill, completely exposed to all the gale-force winds, driving rain and icy hail through every point of the compass and each season of the year.

It is true that there are not many chapels built on the tops of hills like this but if you take the trouble to visit (it is only a ten-minute or so uphill climb from the village to do it) you will see at once why the monks of Abbotsbury built their chapel of rest and retreat here for quiet contemplation and prayer away from the monastery below. In a sense, it is almost like climbing up to Heaven for when you get there the views are stunning and a sort of peace descends.

Dating from the late fourteenth century, it is very solidly constructed from the local buff-coloured limestone and has high and well-buttressed walls to take a stone-vaulted roof. It feels very much bigger than the 45 feet of its actual length.

The monks dedicated the chapel to St Catherine, who was broken on the wheel by the Roman Emperor Maximus I in the third century AD for standing up for Christians and, according to legend, was carried up to Mount Sinai by angels afterwards. Since then she has been the patron saint of virgins providing help through prayer for those looking for a mate. In the south doorway of the

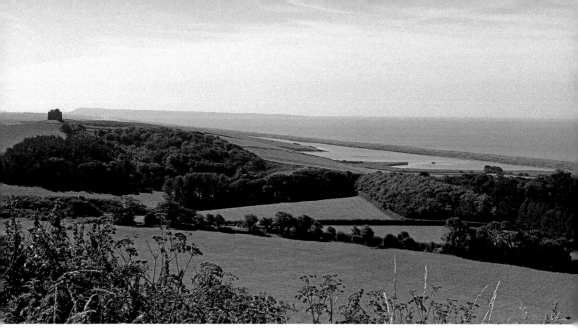

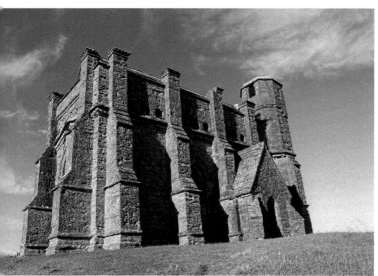

Above: St Catherine's Chapel perched on a hill at Abbotsbury.

Left: St Catherine's Chapel.

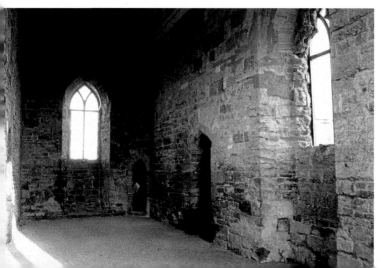

Inside St Catherine's Chapel.

chapel there are the remains of holes for the ladies to put their knees and hands whilst praying for the man of their dreams to come into their lives, a sort of pre-mobile phone Tinder app if you like but with no opportunity to swipe left or right and with no guarantee that there will be anybody out there.

8 Hardy's Monument

For those coming to Dorset afresh, the number of Thomas Hardys can seem rather confusing. There is the Thomas Hardy who achieved international renown with his writing. Then there is the Thomas Hardye (usually but not always spelt with an e), born in the sixteenth century, who founded the school in Dorchester to which he gave his name, and don't forget the naval officer Thomas Hardy who was the recipient of Nelson's last and most famous soundbite 'Kiss me Hardy', which has cascaded down the generations, with all who hear it wondering if that is exactly what he said or precisely what he meant.

It is as a memorial to the naval man that Hardy's Monument was erected by public subscription in 1844, three years after his death and when the writer Thomas Hardy was just a little boy of four.

Hardy's family home in Portesham.

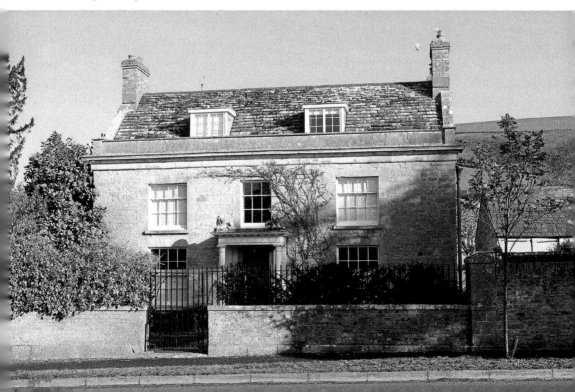

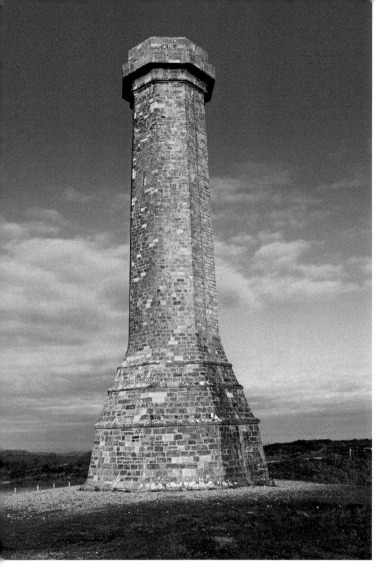

Hardy's Monument.

Born in 1769, Vice-Admiral Sir Thomas Masterman Hardy, Knight Grand Cross of the Order of the Bath, had a distinguished naval career, commanding no less than thirteen warships and taking part in numerous sea battles including those on the Nile, at Copenhagen and as captain of HMS *Victory* at Trafalgar. He became First Sea Lord in 1830 and governor of Greenwich Hospital in 1834.

The monument is an octagonal tower 70 feet high with a battered base and heavy cornice and contains a spiral staircase illuminated by slits in the side. It is built on the highest part of the Ridgeway making it very prominent from a great distance from all angles and, in turn, affording it spectacular views out across the yellow gorse over much of south Dorset and on into Lyme Bay.

Down below in the village is the privately owned Portesham House, which stands on the right-angle bend of the main road, where Hardy lived when home from the sea until his marriage in 1807. It is a fine two-storey building dating largely from the eighteenth century with rubble walls under slate-tiled roofs.

South Dorset

9 Chesil Beach

Chesil Beach is just extraordinary; a long shingle bank extending 8 miles from Portland to Abbotsbury. To the east, a quiet, tranquil and sheltered lagoon made up of part freshwater and part saltwater – a bucolic idyll really and a haven for birds. To the west stands the sea, and what a sea it is. Chesil Beach faces south-west right into the teeth of the prevailing south-westerly gales.

How many winter storms have lashed this beach over the centuries? How much primeval force has been pounded on the pebbles pushing them up and dragging them down? Yet still Chesil Beach stands firm, just as it has always stood, impervious and solid as a shingle shield to the worst that King Neptune can throw at it even when he is in a bad mood and has a headache.

Chesil Beach.

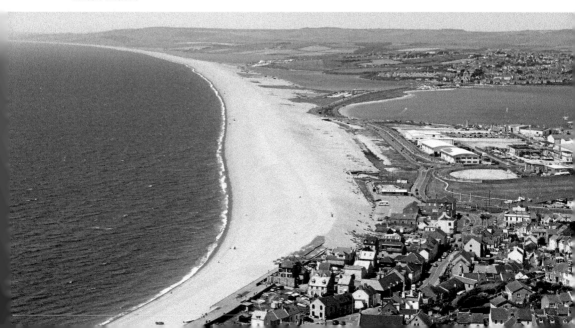

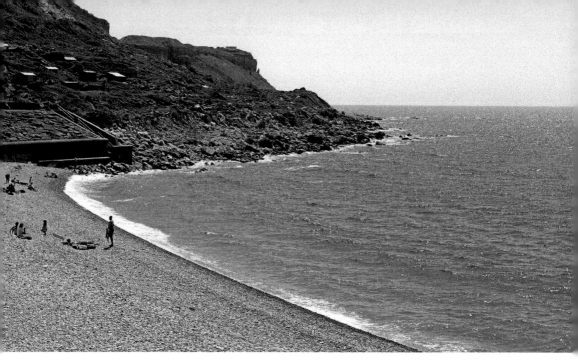

Chesil Beach where it joins Portland.

Chesil Beach has its darker side though. Think of ships before the 1960s without the modern wonders of radar and satellite navigation setting a course up the Channel from Start Point and beyond. It's dark, maybe raining. There is a lot of wind coming up behind you pushing you on. Perhaps the tide is setting a bit more to the north and into West Bay than the captain had thought when he ran the course off on the chart earlier. There is the howl of the wind driving rain through any chinks in the armoury of your oilskin. The ship is pitching heavily and everyone aboard wishes that it wasn't. Then the lookout shouts out 'breakers ahead' and that's it. You are on Chesil Beach and the lovely embroidered handkerchief you bought in Nantucket for your Auntie Sadie in Dorchester will find a watery grave along with all the rest of the passengers and crew.

The list of vessels that have run aground on this deadly marine flypaper is long and the death toll large. Small boats, sailing vessels, coasters, tramps, even ocean liners like the *Winchester Castle* in 1936 manned by the cream of Britain's maritime merchant marine, have all done it. Sometimes in calm weather and fog they have got off again. Usually when there has been wind, they haven't.

On a fine day, it is a different story and a walk along the beach is a real joy. There is a lovely tang of salt in the sea air. There is the unique sound of the sea pushing up and sucking down the pebbles, which start large at Portland and gradually diminish in size along the way. The more adventurous may decide to walk the whole length from Portland to Abbotsbury but be warned, on the shingle you take two steps forward and slide one back. My dad tried it once and afterwards wished he hadn't.

Whatever you do, don't try to swim off it. The current is strong and deadly, and King Neptune has a reputation and hunger for claiming souls here.

10 The Rodwell Trail

The Rodwell Trail follows the route of the old Weymouth–Portland railway line, which opened in 1865 and closed 100 years later. If you walk all the way it is around 4 miles but you can join or leave at various points.

The scenery includes views over the late Victorian and Edwardian tightly packed terraces of Weymouth, through a tunnel and cutting in Rodwell, past Henry VIII's Sandsfoot Castle, where you can stop off for a cup of tea in the gardens, before emerging to give stunning views over Portland Harbour, developed as a Naval Dockyard from the mid-nineteenth century and today a commercial port. There are usually some large ships there taking on bunkers, undergoing repairs or sometimes you might see a visiting liner.

The former railway line at this point is raised on an embankment that stops up the natural valleys sloping down to the sea. Imagine anyone trying to do that today.

At Wyke Regis there is a long apron by the side of the now overgrown old track. This dates from the Second World War and is part of a contingency plan in case the rail and road bridges at Ferrybridge were bombed and destroyed. Repairing one bridge is quicker than fixing two, so the aim was to repair the railway bridge first with a road track along the side of it, which would have continued along this apron before diverting back through Wyke to rejoin the main road there.

Sandsfoot Castle and gardens with Portland beyond.

Rodwell Trail's Second World War contingency plan road.

Between Ferrybridge and Portland the track follows the side of the sheltered beach along the western side of Portland Harbour, often alive with colourful windsurfers. Chesil Beach is on the other side concealing the mighty deep-sea hurly burly beyond.

In its heyday the railway was busy, not least with sailors joining their ships at Portland and going back into Weymouth for a night out in the town. However, as bus travel developed with a greater diversity of pick-up points, the railway could not really compete and was therefore closed to passenger traffic in 1952. Its real strength was in shipping out Portland stone, which had previously been moved off the island by sea, and this service continued until the final axe fell in 1965.

11 Church Ope Cove, Portland

Church Ope Cove is a sort of secret place hidden away from prying eyes. It is surrounded by cliffs on three sides and is just the sort of location to land contraband property or bring in a couple of Russian spies dropped from an inconspicuous fishing boat, as happened in the Cold War with the assistance

of Harry Houghton, a clerk at the nearby Admiralty Underwater Weapons Establishment, who was arrested in 1961 as part of the Portland Spy Ring.

It is a place unlike any other on Portland. Elsewhere there is a sense of bleakness and the absence of many trees, but here trees grow in prolific abundance and the view is spectacular. Small wonder that John Penn, grandson of William Penn, who founded Pennsylvania in America, chose to build a mansion, Pennsylvania Castle, on the top of the cliff overlooking the cove in 1800.

The path down starts by the side of the Portland Museum, which is in a cottage once owned by Marie Stopes, pioneer of birth control. On the way, you pass what remains of Rufus Castle, now privately owned and generally inaccessible. Its origins go back to the twelfth century, although much of what remains dates from 300 years later. It is of pentagonal shape and built of blocks of Portland stone with corbels on the top with machicoulis, which is a fancy way of saying holes through which stones could be dropped on the heads of invaders underneath.

After that the view opens up in stunning form showing the ruins of the medieval church of St Andrew on the right and the steps down to the beach, which in my experience always seem far more numerous on the way back up than they did on the way down.

There are some small wooden beach huts, which are much sought after when they become available, and there is a bit of magic sitting there on the beach looking out to sea. You can take a dip if you want but I wouldn't go too far out due to the sometimes quite strong currents. We are only a couple of miles from the treacherous Portland Race here.

Church Ope Cove.

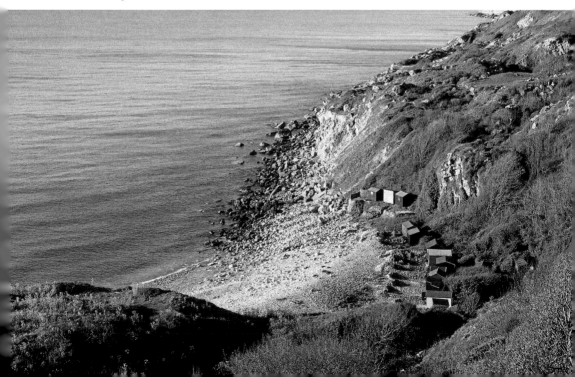

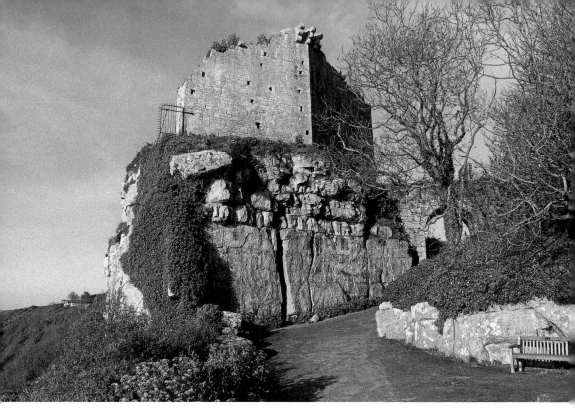

Rufus Castle.

Church Ope Cove was never regularly served as a destination by the local paddle steamers of Cosens, but I have seen a picture of their *Premier* here with her bow up on the beach landing passengers for a tea party in the grounds of Pennsylvania Castle in July 1911. What a happy day that must have been.

12 Weymouth Promenade and Beach

Weymouth is where the fashionable seaside holiday started. Toffs and aristocrats visited from the mid-eighteenth century to take up sea bathing, encouraged by the legendary entrepreneur Ralph Allen of Bath. The king's brother was one of them and he liked it so much that it was inevitable that the king came too. Between 1789 and 1805 George III made Weymouth his home during most summers and what the king endorsed anyone of sufficient status and wealth wanted a part of too.

Pevsner describes Weymouth as the Georgian seaside resort 'par excellence' and in this he is spot on. The buildings along the promenade are Georgian at its best. Facing south-east onto the sea they are protected from the prevailing south-west winds. Even in easterly gales you feel safe as the sands are so gently shelving keeping the sea at bay.

Compare that with Brighton, put on the seaside map by George III's son, who became Prince Regent. He built his Pavilion and other regal accessories behind and away from the Brighton promenade with its less than hospitable beach when the wind blows up channel. Not so at Weymouth. Gloucester Lodge where George III stayed is right there on the front like all the other grand buildings looking out onto and enjoying the wonderful views out to sea.

That the Prince Regent decided to cast his seaside favours on rival Brighton did not go down well in Weymouth. Celebrity endorsement counted for as much then as it does today so to counter this and keep the regal connection in the minds of potential visitors the very large King's Statue was commissioned and erected in a prominent position in 1809. After that nobody visiting Weymouth would ever again forget that George III had liked the town and put it on the holiday map.

In 1887, another iconic landmark, the Jubilee Clock, was erected on the promenade to celebrate Queen Victoria's fifty years on the throne.

The buildings, of course, are not the end of it. It was the beach that attracted the gentry, and what a beach it is. It has a rise and fall of tide of only 2 metres or so with no currents to speak of, which make it very safe, and has a particularly fine sand that lends itself to the building of sandcastles. Try making similar Weymouth-style spectacular sandcastles and sculptures on the breach at Brighton and just see how far you get.

In Victorian times, the visitor profile started to change from the aristocratic to the mass market. In my childhood, in the 1950s, the beach was packed to

Weymouth's sandy beach and Georgian promenade.

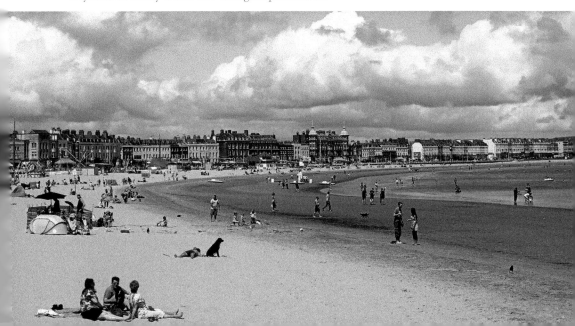

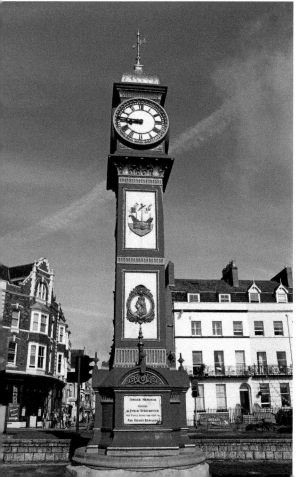

Above: Punch and Judy show on Weymouth Beach.

Left: Jubilee Clock on Weymouth Promenade celebrating fifty years of Queen Victoria's reign.

bursting in the peak weeks with holidaymakers enjoying their one- or two-week annual holidays from the car and other factories in the industrial heartlands of the Midlands and Wales.

Today, Weymouth is still a bucket and spade resort. Think kiss me quick hats, boozers, and Punch and Judy – but don't stop your thinking there. Remember that Weymouth has, in architectural terms, one of the finest Georgian seaside promenades anywhere in England.

13 Weymouth Harbour

Weymouth Harbour divides what were once two separate towns, Weymouth to the south and Melcombe Regis to the north, which co-existed in a prickly and sometimes quarrelsome sort of way until amalgamated in 1570 when a bridge was built connecting them and replacing the previous rope-drawn ferry.

The harbour was at the centre of my boyhood world and dreams. There were the Channel Island mailboats and cargo ships served by a railway line, which ran down the middle of the road and was sometimes held up by cars. Paddle steamers filled the Backwater in winter and ran excursions in summer. There was a flourishing wood trade coming in to Custom House Quay and sand dredgers unloaded their cargoes, which they had sucked up from off the Needles, for the building trade. Today all that commercial shipping has gone and the harbour is filled with yachts, small fishing boats and the occasional visiting tall or excursion ship instead.

To get the best feel of the ambiance of what remains a delightful harbour, start at the end of Devonshire Buildings on the promenade and walk along the old raised cargo jetty. The Channel Island tomatoes and flowers used to come in here. Make sure to look across at the wonderful late eighteenth- and nineteenth-century cottages on the other side with the former army barracks, built for troops to protect George III on his visits, beyond. Have a pint or a pie in one of the several pubs before you reach the town bridge or buy some fresh local fish or a tub of whelks from Colin Horne's wondrous fish market. This is a popular area for sitting, gossiping and gawping while soaking up the boating atmosphere in this gentle harbour.

Cross the lifting bridge, opened by the future George VI in 1930, for more eighteenth- and nineteenth-century houses including one once owned by Ralph Allen, who put Weymouth on the social map. Take a trip on one of the small passenger launches, or mackerel boats. Don't fall over the large mooring rings, still embedded in the roadway, which once served the railway steamers laid up in the cove.

Carry on along the south side of the harbour past the remains of the little eighteenth-century shipyard, the lifeboat and sailing club until you come to a small ferry that operates in the summer in fine weather and takes you back to where

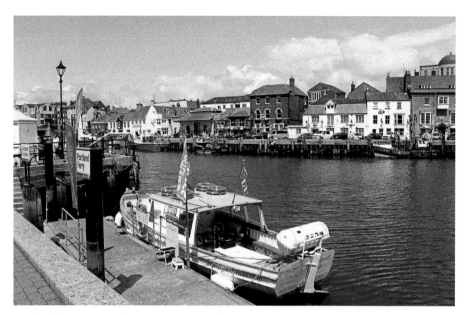

Portland ferry *My Girl* in Weymouth Harbour.

Rowing boat ferries carrying passengers across Weymouth Harbour.

you started your walk at Devonshire Buildings. The ferry is a bit of a gem in itself. The boats carry only eight passengers and are propelled by oars, usually pulled by ancient mariners just as they have always been down through the generations. This is how they used to do it before noisy and polluting engines were invented.

14 Upwey

Upwey is one of my favourite places and was a regular Sunday afternoon walk in my childhood. We usually started at the south end at the bottom of Stottingway Street between Upwey Manor and Westbrook House. Both date from the early seventeenth century, although the latter was substantially rebuilt in Georgian times. They are substantial properties hiding themselves away from the outside world in their cosy bowers. Who knows what exciting and influential conversations went on behind their closed doors down the centuries?

You can stand right by the small and gentle River Wey here as it bubbles along on its peaceful way, descending occasionally over waterfalls of a similarly modest scale, which rarely exceed a drop of more than two feet.

Walking north along the side of the road you pass charming cottages, a Methodist chapel and one property containing in its surround a small statue of Charlie Chaplin, which has been there for as long as I can remember.

At the north end of the village you come to the Wishing Well, which is the source of the River Wey, and the church. Visitors started coming to Upwey in Georgian times to take the water and make a wish, and the well has retained its popularity ever since. There used to be a corrugated-iron shack serving teas here. Today that has been replaced by a purpose-built tearoom through which you will need to pass to access the well itself.

River Wey at Upwey.

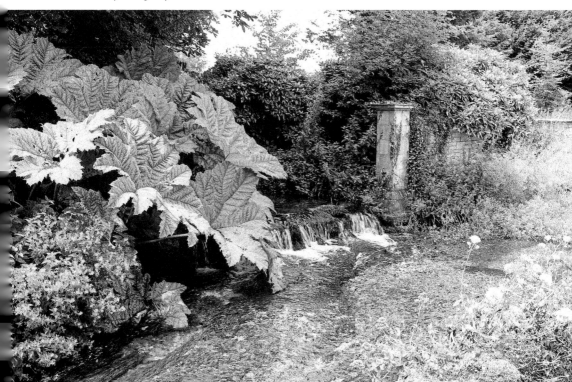

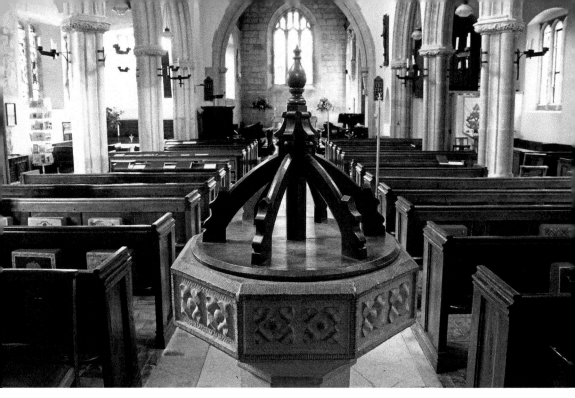

Inside St Laurence Church, Upwey.

The former village school next door sometimes hosts art exhibitions and St Laurence Church beyond that is a delight tucked away between the hills. Parts of the church including the porch and north aisle date from the fifteenth century but much of the rest came later in rebuilds around 1838/41 and in 1907. The pulpit is Jacobean, of elaborate construction and was described by the late and great writer on the buildings of Weymouth Eric Ricketts as 'the finest oak pulpit of the period anywhere in Dorset.'

You can carry on up the surrounding hills on paths and sit at the top to take in the perfect ambiance of the surroundings. There is a quietness here. As King Lear might have said, 'Blow winds and crack your cheeks, rage blow elsewhere I think but not down here in Upwey -oh!'

15 Ringstead Bay

If Weymouth Beach is a bit too crowded for you and you fancy a dip in Dorset's crystal-clear coastal waters, then Ringstead Bay is the place to go. It is not as sandy as Weymouth – more shingle and small pebbles underfoot instead – but the location makes you feel that you really are communing with nature rather

than swimming in a fine film of other people's suntan lotion. There are some reefs off the beach that are exposed on low tides and the whole area is awash with wildlife and flowers as well as butterflies in season adding their own inimical splashes of colour to the landscape. There is even one butterfly first spotted in the area in 1832 and named the Lulworth Skipper.

If you fancy a walk, climb up the path past Burning Cliff to the top of White Nothe, which, at 500 feet, is the tallest part of the Dorset coast here. It is a bit of a hike but well worth the effort for the views across to Portland and Weymouth in the west and on past Durdle Door and Kimmeridge to St Alban's Head around 10 miles to the east.

Set back from the top of the cliff is a row of former coastguard cottages, which, given the isolation of the place, always seem a tad spooky to me. I wish that man outside of one of them chopping wood with a big axe didn't have quite such piercing eyes and why is he suddenly waving me over with a smile that seems to hover between welcome and menace? Was that a scream I heard or was it just a sparrowhawk catching a dove? Of course, in my rational self I am quite sure that I would find the cottages a real delight inside, and populated by really nice people, if only I could ever pluck up enough courage to go any closer to them rather than quickening my step to hurry on.

The beach at Ringstead was involved in a little Cold War activity with two giant and circular radar aerials plonked down to give early warning of a Soviet attack in the 1960s. They were removed in 1974, although parts of their base remain visible today.

Ringstead Bay with White Nothe beyond.

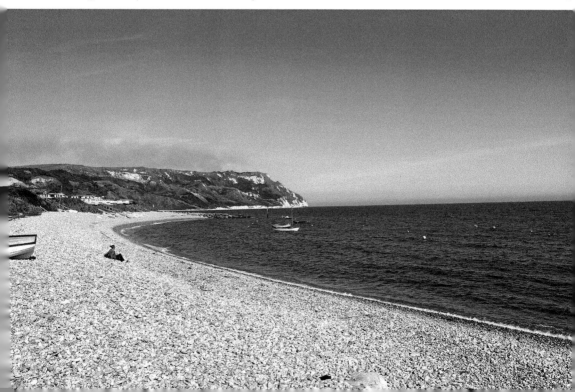

Looking towards White Nothe and the former coastguard cottages.

16 Lulworth Cove

As a boy, my parents often took my brother and me to Lulworth Cove on the paddle steamer *Consul* from Weymouth, out at 10.30 a.m. for a non-landing round trip and back at 12.30 p.m. or at 3 p.m. for an hour ashore. Along the Dorset coast, past White Nothe, Durdle Door and then: where is the cove? It's hard to see. Oh yes, a little gap, not obvious at all. Keep her up to the east, more water there and then inside to this wondrous, glorious, massive and hidden cove. Wow!

The Weymouth guidebook for 1880 describes Lulworth as one of the most romantic spots. 'No more picturesque place is found on the English Coast surrounded, as it is, by steep limestone hills. On a summer day, the water is placid beyond expression and everything around affords facilities for the enjoyment of health giving activity or wholesome rest. It is the Paradise of those who are glad to escape the hurry and strain of the busy towns and is a place where the botanist, mineralogist or geologist could also pursue study profitably'.

Consul put her bow up onto the shingle shelving beach in the north-west corner of the cove. A wooden gangway on massive wheels was rolled down. The passengers went ashore and meandered on up the little rough-hewn track towards the village past the lobster pots, the hauled-out boats, the tiny cottages – how could people stand up in some of them without banging their heads? – and the duck pond alive with honking geese and quarrelsome crows. It was such an adventure to my young self, made all the better by the final prize of a Walls ice

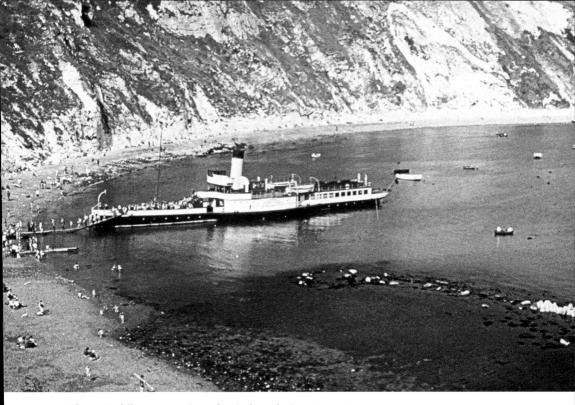

Above: Paddle steamer *Consul* at Lulworth Cove in 1962.

Below: The little track at Lulworth up from the beach.

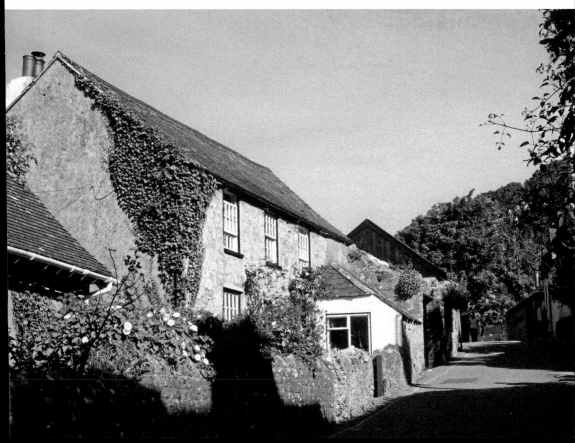

cream cornet sold from a tiny wooden kiosk at the top before we all retracted our steps back to the beach to board *Consul* for the voyage home.

It is thought that the boat carrying Keats across the Channel in September 1820 put into Lulworth Cove, inspiring him to write his poem 'Bright Star'. Thomas Hardy penned his own tribute to this event *At Lulworth Cove a Century Back* in which he depicted Keats as 'Of an idling town-sort; thin; hair brown in hue' on his way 'to Rome – to death, despair'.

Well, if you wanted to have a last memory of England on your downward trajectory to decline, then you couldn't do better than soaking it up at Lulworth Cove.

17 Lulworth Castle

Lulworth Castle was built in the early seventeenth century for Thomas Howard, 3rd Viscount Bindon, who had his main seat at Bindon Abbey not far away at Wool. It is of square shape with large round towers on each corner with battlements along the top, which make it look like a warlike castle. In fact, it was built as a lodge or subsidiary residence for occasional use when the viscount

Lulworth Castle: a country house designed to look like a castle.

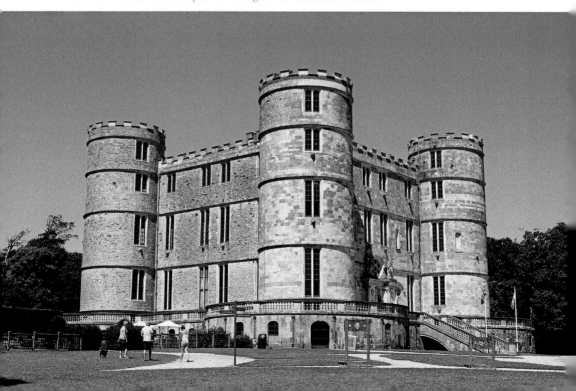

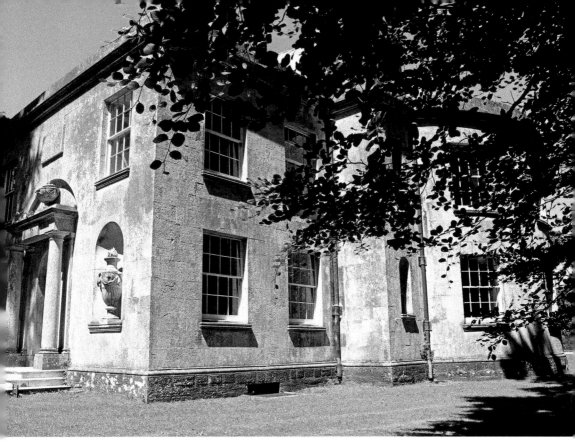

St Mary's Roman Catholic Church was designed to not look like a church.

was away from his main residence and entertaining his guests. The front to the east is Purbeck ashlar with the other sides of coursed rubble.

In 1641, the castle was bought by Humphrey Weld, who made it his main home, and it has remained in the ownership of his descendants right up to this day.

Unfortunately, a fire in 1929 destroyed the interior and what remained lay exposed to the elements for decades with Mother Nature trying to claim back her rights, sending in her teams of ivy and other vegetation to engulf the fire-damaged walls and with what remained of the wooden panelling gradually rotting away. Vandals also removed a balustraded terrace dating from the early eighteenth century.

Restoration work in association with English Heritage began in the 1990s and in 1998 the castle opened to the public. For me the best bit is climbing to the top of the tower, from which the views are spectacular.

In the grounds is the Roman Catholic Chapel of St Mary, which was built in 1786 by special permission from George III on condition that it should not look like a church. At that time Catholicism was not acceptable and this is the first Catholic church to be built in this country after the Reformation. It fulfils the king's requirement in that from the outside it looks a bit like a cross between a small country house and a temple. Inside there is a wondrous dome.

18 Tyneham

As I write this, news has just come through of a horrific fire at a tower block in London in which many have died. Coming in the aftermath of various terrorist incidents, the outlook seems bleak and distinctly unsettling. Of course, it is dreadful, no question about that. But to put it in perspective turn the clock back to 1943 when my parents were in their twenties. The whole world was at war then. There was conflagration everywhere. Whole cities were bombed. Hundreds of thousands and more were dead. Here in this happy, sleepy Dorset backwater, the residents of Tyneham, many of whom had lived here generation upon generation, were rounded up and chucked out from their safe and secure homes. The War Office needed land to practice gunnery. They chose this isolated part of Dorset. That was that.

Tyneham still lies within the Ministry of Defence gunnery area with gates and red flags warning off all comers, but it is open on some weekends and during holidays when the practice gunnery is on hold. It is well worth a visit.

There is something unsettling about visiting a village populated only by ghosts of another time with its now ruined remains of the old cottages where

Abandoned cottages at Tyneham.

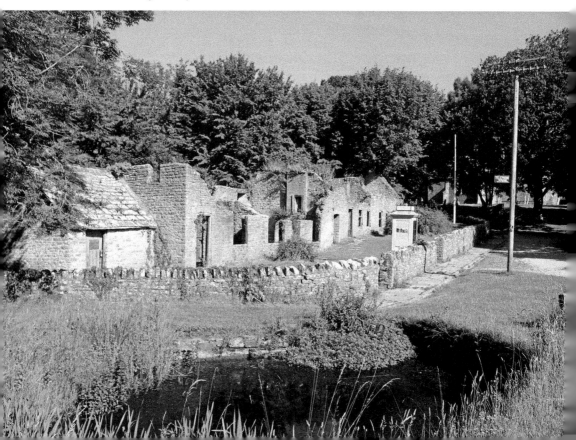

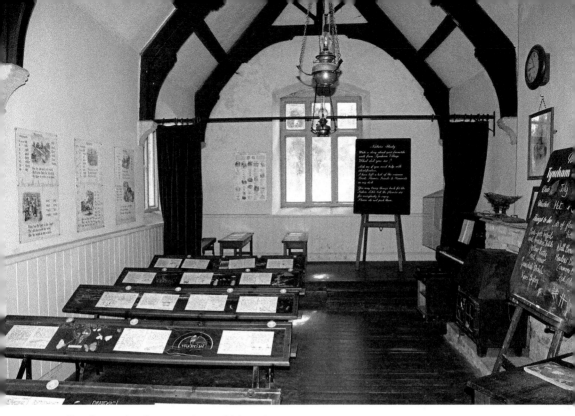

Tyneham schoolroom as it would have been.

once people lived. The little largely nineteenth-century church with its medieval transept is still there and so is the Victorian schoolroom, which has been set up as it once was with little tables and chairs plus the teacher's blackboard.

Walk on half a mile to Worbarrow Bay, which has a fine shingle beach surrounded by tall cliffs and view out into the Channel and across to Portland. There are several Iron Age hill forts in the area both on the top of the first chalk cliff and to the north of the village. The ghosts are not just from the Second World War.

Mid Dorset

19 Maiden Castle

The thing that always strikes me about Maiden Castle is its huge size. It is just so big, so big in fact that, like hiding an object in plain view, if you didn't know that you were looking at the largest and most impressive hill fort in Europe, you might miss it completely thinking it is just another large hill forming part of the natural landscape.

How did societies, primitive in comparison with the engineering competence and standards of today, put it all together and live in what must have been a quite sophisticated social order working for the greater good of all, centuries before the Romans came, bringing with them their own and a very different form of civilisation.

The origins of Maiden Castle date back over 6,000 years to the Neolithic era after which its fortunes waxed and waned. It was during the Iron Age from 800 BC onwards that the structure of the landscape really started to change with the final form being developed after around 150 BC.

The footprint covers over 47 acres. There are entrances at both the eastern and western ends. The whole thing is surrounded by a series of ditches, which provide considerable obstacles to any who might want to attack. In the central plateau section are the remains of a long barrow and a Romano-British temple built in the fourth century AD and typical of similar structures constructed in remote locations at that time.

Sir Mortimer Wheeler excavated the site in the 1930s and found a cemetery with people buried together with some of their personal possessions including beads, rings and pots. It is thought that, at its peak, life was well organised inside the fort with small round houses set out in rows within the central plateau together with storehouses for grain and a primitive form of drainage.

In 43 AD the Romans came, saw and conquered, establishing the town of Dorchester as Durnovaria nearby after which Maiden Castle fell into disuse. Today its inhabitants are sheep.

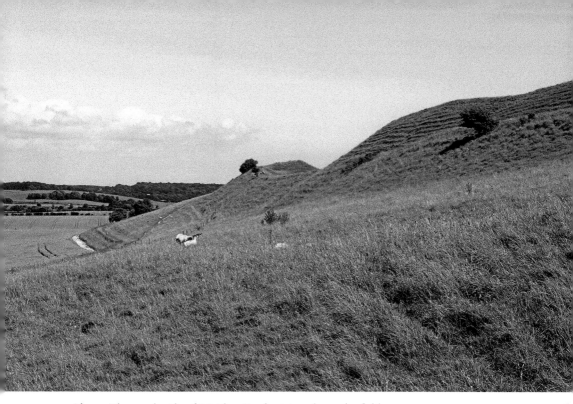

Above: The north side of Maiden Castle rising above the fields.

Below: Looking south-west from Maiden Castle over some of the defence trenches.

20 Thomas Hardy's Cottage, Bockhampton

Thomas Hardy was born in 1840 in this cottage built by his grandfather of cob under a thatched roof. It is in the heart of the Dorset countryside right next to Thorncombe Woods and not far from the heathland that Hardy would subsequently immortalise in his books as Egdon Heath.

Standing there today in this flower-filled cottage garden with woods on three sides, you can imagine this bright little boy watching, looking and taking in everything of people and place around him. At once you will understand where the first paragraph of his novel *Under the Greenwood Tree* comes from.

> To dwellers in a wood almost every species of tree has its voice as well as its features. At the passing of the breeze the fir-trees sob and moan no less distinctly than they rock, the holly whistles as it battles with itself, the ash hisses amid its quiverings, the beech rustles while its flat boughs rise and fall. And winter, which modifies the notes of such trees as shed their leaves, does not destroy its individuality.

When Hardy was a boy, Dorset was on the cusp of change. On the one hand, most life went on much as it had done for generations; on the other things were moving on. The railway arrived at Dorchester when Hardy was seven and what a project that must have seemed to an impressionable little boy with all the cuttings, embankments, smoke and steam driving their way through the bucolic Dorset countryside.

Hardy's parents and grandparents were builders but the more bookish young Thomas did not follow them into the family business. Instead, when he was sixteen, he became a pupil of Dorchester architect and classical scholar John Hicks and continued with this profession on and off for the next fifteen or so years based in Dorchester, Weymouth and London.

In London, Hardy was involved in the designs for St Pancras railway station and in his spare time took every opportunity to visit galleries, the theatre and the opera. He had an insatiable hunger for knowledge and benefitted from the help and advice of several key figures in his life including his close friend Horace Moule, who later committed suicide. There is perhaps a little bit of Horace in Michael Henchard, *Mayor of Casterbridge*. a man of intelligence, ability and charm but deeply flawed and, in the end, the architect of his own downfall.

Hardy was thirty when he visited Cornwall for work on behalf of Dorchester architect Crickmay, or as he later put it, 'When I set out for Lyonesse'. There he met his own Isolde, Emma Gifford, with whom he fell madly in love.

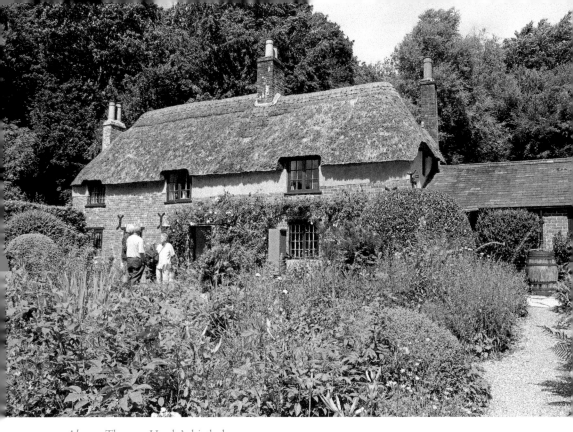

Above: Thomas Hardy's birthplace.

Below: The parlour inside Hardy's cottage.

He was still then living intermittently at Bockhampton and writing *Under the Greenwood Tree* in his childhood bedroom, often putting in a couple of hours from 5 a.m. before setting off for the day job. This novel was to make Hardy's name and led to more lucrative offers to serialise his later books, which would produce income on a grander scale and transform both his and his wife-to-be Emma's lives.

21 Dorchester

Dorchester is not the biggest town in Dorset but it is the county town and for me, despite its many virtues, it has a sense of earnestness about it.

Perhaps it is the late Victorian prison, now closed, with its massive red-brick walls where Thomas Hardy once saw a hanging and wished afterwards that he hadn't. Perhaps it is Judge Jeffery's lodgings, now a restaurant. He was not a kind man and the disproportionate cruelty that he unleased in the aftermath of the Monmouth Rebellion sends a shiver down my spine every time I think about it. Then there is the Hangman's Cottage down by the Frome. It is such a lovely setting with the silvery shallow river shimmering by but it is still the Hangman's Cottage. Above that is Colliton Park, the huge 1930s County Hall complex built to house the bureaucracy to order Dorset life. There must have been a good deal of bossing about going on in there over the years.

However, don't let me despond you too much. Dorchester has another side. There is the massive former Eldridge Pope Brewery at the south end, which once brewed the intoxicating liquor to uplift the locals, visitors and militia alike and is now developed with a cinema and eateries.

Don't forget Maumbury Rings, a Neolithic henge adapted by the Romans as an amphitheatre. Take a walk down the High Street and enjoy the eighteenth- and nineteenth-century façades including the Antelope Hotel of 1815 with its carriage entrance, the Corn Exchange of 1848 with its later addition of a corner clock turret, St Peter's, the only surviving medieval church in the town, and Shire Hall of 1797 where the Tolpuddle Martyrs were put on trial.

Ah yes, where the Tolpuddle Martyrs were put on trial. That rather brings me back to where I came in. Some towns ooze fun and some don't. Some are a bit arty and some aren't. Some have the hint of being Royalist about them while others would swear to the Parliamentary cause come what may.

For me, Dorchester has rather the feel of a town with a pencil jammed behind its ear ready to record something, somewhere about someone in a notebook and in so doing take proper action to make sure that the perceived miscreant, judged by the standards of the town, is put straight.

Above: Hangman's Cottage, Dorchester.

Right: Dorchester's Corn Exchange of 1848 with the clock tower addition of 1864.

22 Dorset County Museum

When I was a boy I sometimes caught the red Salisbury bus from Weymouth to Dorchester on my own on a Saturday morning to spend an hour or two meandering around the Dorset County Museum gazing at the fascinating exhibits and absorbing the atmosphere of the place.

The Victorian Gallery was then, and remains today, awe-inspiring with its spindly and colourful cast-iron structure extending upwards giving a real sense of space, with a huge rose window at one end and a narrow gallery around the sides filled with artefacts, pictures and maps, which tell something of the history of Dorset and Dorchester. The floor contains mosaic taken from excavations of Roman buildings in Dorchester.

Elsewhere in the museum, there are collections of items from Dorset's rural past, much about the Jurassic era, details from excavations of local barrows from the Paleolithic to Roman times as well as a gallery on literary Dorset and writers who made their homes in, or were much influenced by, the county. In this there is Thomas Hardy's study taken from his house Max Gate in Dorchester and reassembled in the museum. It always fascinated me as a child, and still does

Dorset County Museum, Dorchester.

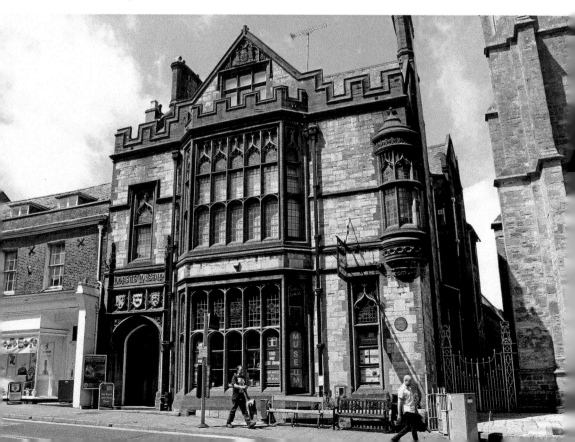

today, to see Hardy's desk and pens, his inkwells and blotter, his books around the walls as well as the day-to-day stuff including his walking sticks and violin.

The museum was built between 1881 and 1883 by Crickmay & Son of Weymouth with the front of the building looking out onto High West Street in the Gothic Perpendicular style with a two-storeyed bay window and a bow-angled oriel. It was part of the Victorian ideal of collecting to display and thereby educating a wider populace in the wonders of history and the natural world.

That is a concept that comes and goes in popularity according to the whims of fashion but for me I think that it should be a constant. I didn't keep coming back to the museum as a boy through any worthy sense of education or improving myself. I did it because I just loved being there and looking at all the fascinating stuff.

23 The Keep Military Museum, Dorchester

The Keep Military Museum in Dorchester tells the story of the regiments of Devon and Dorset that went off from their rural homeland to fight for king, queen and country in wars all over the world. It is set in the gatehouse of the former army barracks built in the late 1870s and designed by Major A. C. Seddon to look like a Norman castle with two massive round towers on each side, a central archway and long slit windows reminiscent of the days of bows and arrows rather than large cannons. The site was the administrative base of the Dorset Regiment and was used for recruitment and training until 1958.

Today it looks a bit odd and somewhat out of place, to me anyway, sitting there surrounded by the trappings of a more modern and fast-moving part of Dorchester where most who pass by now, scurrying on with their own pressing business, are largely unaware of the multiplicity of personal stories, heroic, tragic and mundane that the keep's walls conceal.

Think of all those young men, idealistic, brave, cocky and wishing for the glory of a good deed well done for a worthwhile cause, who passed through these gates. The brass buttons that were polished and the colourful tunics donned around the town to impress the girls. The spurs clink, clink of regiments of renown. The voyages out not only to Europe but beyond to Asia, India, Egypt, Afghanistan and South Africa. The boredom of sitting around waiting for the battle and then the triumph of success or the sheer unrelenting ghastliness of seeing comrades killed.

Think of the triumphal returns parading through the Dorchester streets with flags on high and bugles a-blare. Think too of the mothers and widows tearful

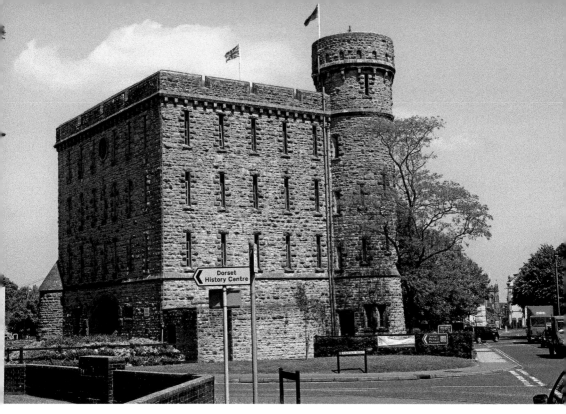

The Keep Military Museum, Dorchester.

in Fordington, Upwey or Bridport wondering whatever to do next, where they would live now and how they would feed their children as Army pay stopped on the day of death.

Similar young late Victorian soldiers were immortalised in the poetry of A. E. Houseman in 'A Shropshire Lad': 'The street sounds to the soldiers' tread, And out we troop to see, A single redcoat turns his head, He turns and looks at me.'

Thomas Hardy had mixed views of war. In 1924, he wrote: '"Peace on earth!" Was said. We sing it, and pay a million priests to bring it. After two thousand years of mass we've got as far as poison-gas.'

24 Max Gate, Dorchester

As a trained architect, Thomas Hardy designed Max Gate himself. It is built of plum-coloured brick with turrets on each end and a central gable, and, in my view, is a distinguished Victorian gentleman's house declaiming to the outside world that its owner is a man of substance. However, not everyone agrees. Pevsner declares that 'it has no architectural qualities whatever'. Oh dear.

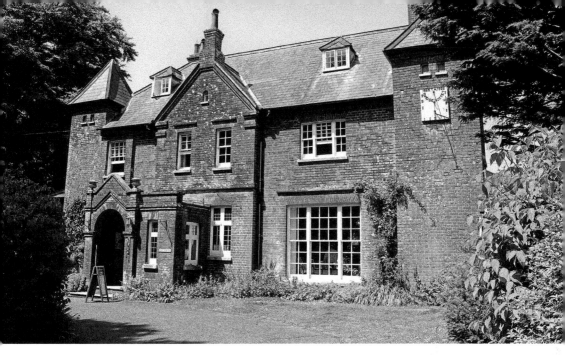

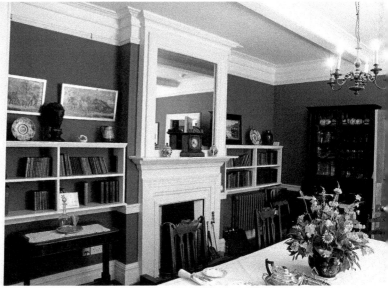

Above: Max Gate, Thomas Hardy's home from 1883 until his death in 1928.

Right: The dining room at Max Gate. Compare it with the parlour at Bockhampton.

Hardy himself was aware of the gap between what clients might want of a building and what architects might deliver, and penned a witty but in the end rather gloomy poem about this called the 'Heiress and the Architect' in which the architect bats away all the heiress's grandiose dreams in favour of more practical realities including making sure that the staircase is wide enough to get a coffin up and down.

Max Gate is surrounded by trees, many of which Hardy planted, and has a side door leading to a gate in the garden wall, out of view from the front door, down which Hardy could escape if any unwelcome guest lifted his knocker.

Hardy was a very private man of whom it was sometimes said that he preferred walking down the middle of the road in Dorchester so that he did not have to bump into people on the pavement. However, like many private people, he was convivial in the right company, could be garrulous on topics that interested him and was never slow to pick up his violin or trip the light fantastic. 'The dance it is a great thing, a great thing to me, with candles lit and partners fit for night-long revelry.'

Hardy moved to Max Gate in 1883 at the height of his fame as a novelist. He penned *The Mayor of Casterbridge, The Woodlanders, Jude the Obscure* and *The Well Beloved* there but after that, although he lived until 1928, he gave up novels and devoted much of his time to other writings, in particular poems of which there are almost a thousand.

Some pictures of Hardy make him look a little dour but this doesn't seem to have stopped him being something of a hit with the ladies. His relationship with his first wife Emma was intense, although that cooled when he met Florence Dugdale in 1905. After Emma died in 1912, Hardy married Florence and shortly after that started writing love poetry to his first wife. Complex indeed is the realm of human emotions.

25 Clouds Hill, near Moreton

Think of the vast canvas of David Lean's epic film *Lawrence of Arabia.* Think Peter O'Toole, at 6 feet 3 inches tall, portraying T. E. Lawrence, who was only 5 foot 5, dolled up in Arab kit and charging into battle astride a camel with his fighters swirling their guns in tow. Think guerrilla activities blowing up railway bridges to stop the Turks. Then come to Clouds Hill and see how a hero of legend lived.

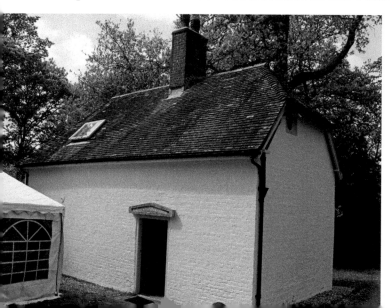

Clouds Hill, last home of T. E. Lawrence, aka Lawrence of Arabia.

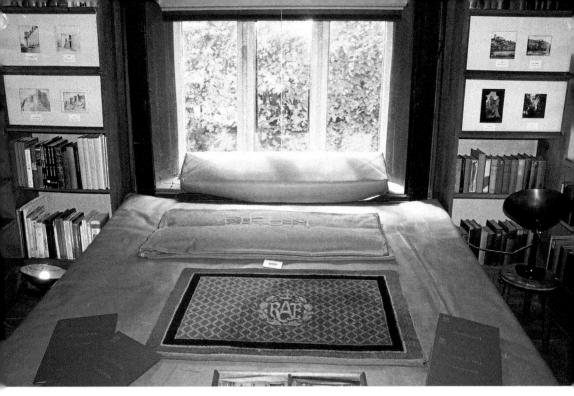

Lawrence's book room on the ground floor at Clouds Hill with a bed.

When I first visited this tiny cottage years ago the first thing that struck me was its remoteness, tucked away out of sight among woods. The second thing was that the south-facing sun-gathering wall sits blindly devoid of any windows. This is not a cosy nook that looks out onto its rural idyll but one which turns inwards keeping the outside world at bay.

The small main room on the ground floor is dominated by a huge bed capable, if required, of accommodating several. The walls are lined with books. At one end, there is an open fireplace for a roaring winter fire. At the other is a small Gothic-style window taken from the ruins of nearby Binden Abbey, all together giving the room the feel of a small don's study at an Oxbridge college.

Upstairs there is a music room that feels like an attic, as there is no ceiling under the roof, containing a wind-up gramophone with the largest horn I have ever seen. Next door is the guest bedroom or rather tiny cabin with its sea-going-style bunk at one end atop a chest of drawers.

After the First World War Lawrence turned his back on the trappings of his formidable wartime success in the Middle East and, despite holding the rank of colonel in the Army, decided instead to enlist first as an ordinary aircraftsman in the RAF and then as a private in the Royal Tank Corp serving at Bovington Camp under the name T. E. Shaw.

Any who likes their heroes to be straightforward will be disappointed by Lawrence. He was a complex man, spy, guerrilla, warrior, confidante of government ministers, writer, thinker, officer and also a practical man who enjoyed the nuts and bolts of fixing tanks in the company of young men whose horizons, outlooks and abilities were very different from his own.

Lawrence liked extremes. He liked pushing the boundaries. He liked fast motorbikes and on 13 May 1935, aged only forty-seven, he crashed into two boys on their pedal cycles not far from Clouds Hill. He died in hospital six days later.

26 St Nicholas Church, Moreton

Dorset towns and villages are stuffed full of churches. Big ones, little ones, those dating back to the medieval world, Victorian ones aplenty, you name it and you will find a delightful church somewhere in the county to fit your own bill and tastes.

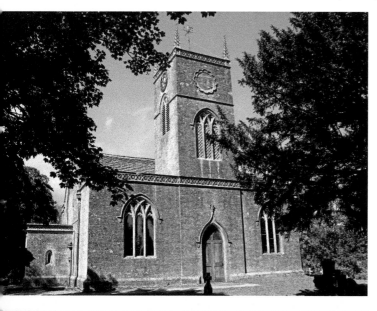

St Nicholas Church, Moreton, with its south-facing tower and frieze of roundels.

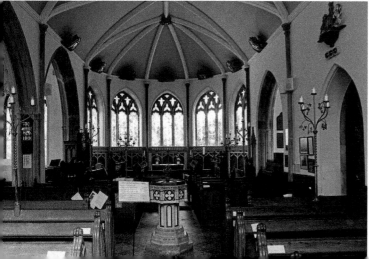

St Nicholas's wide apse around the altar with Whistler's engraved-glass windows.

Among all these, St Nicholas Church in Moreton is special not only because it represents Georgian Gothic architecture at its very best but also because of its engraved glass windows designed and executed by Sir Lawrence Whistler to replace those blown out by a stray bomb in the Second World War. You and I might have thought that in the Blitz that destroyed so much of our major cities, sleepy little Moreton would have been safe away from the action but in that we would have been wrong. Bombs fell on Moreton too and although the church survived, its windows didn't.

The previous medieval church was demolished and the present one built in 1776 by James Frampton. Additions were made to the aisle in 1841 and the west porch in 1848 but otherwise this is very much a Georgian church. The true genius of the design is the wide nave with ribbed vaulting leading to a spacious apse at the eastern end with large windows now containing Whistler's post-war engraved glass. These allow light to flood onto the altar making an effect unlike the more usual stained glass of church windows. Here the glass is clear and you can see through to the trees beyond with the stunning engravings seemingly floating on the light as it enters the church.

The grave of T. E. Lawrence is in the newer burial ground to the south of the church.

27 Tolpuddle Martyrs, Tolpuddle

Tolpuddle is not a gem because of its scenic wonder. Lying on the old main road between Puddletown and Bere Regis, it is a perfectly respectable Dorset village with its own share of thatched cottages but it is not up there with the greats if you want the sort of village that has chocolate box appeal, honeysuckle and bucolic contentment. Rather it is a gem because it is a reminder of another age, a time when ordinary people were not always treated well.

The 1820s were a difficult time. The labour market was flooded with troops and sailors who had fought in the Napoleonic Wars. There was civil unrest and riots. On top of that mechanisation was starting to appear in a rural landscape otherwise largely unchanged for generations, sowing the seeds of fear that jobs would go. A good threshing machine could put dozens of labourers out of work overnight.

Local landowners, including James Frampton from Moreton, who had been travelling in Europe in 1791, remembered the French Revolution only a few decades earlier and how the mobs there had swept away the French ruling elite putting many of them to the guillotine. In this melee of social change, the idea of unions started to be fostered and that did not go down well with the rich and powerful who feared a re-run in England of what had happened in France.

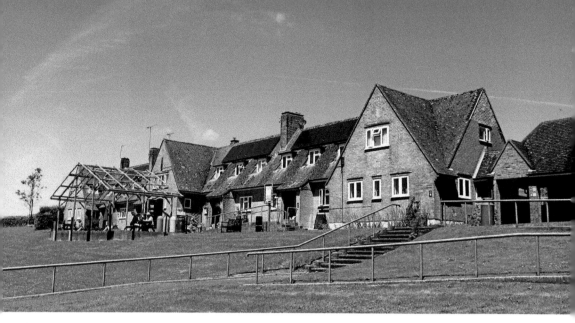

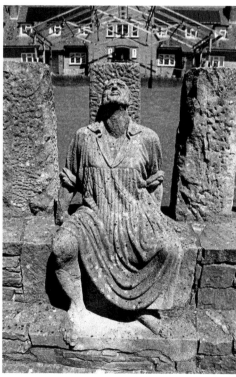

Above: The TUC's 1937 Memorial Cottages at Tolpuddle.

Left: Thomas Dagnail's 2000 sculpture of George Loveless in despair before his transportation.

Frampton, who had powerful connections in London, decided to take a stand in 1834 and managed to arrest a group of farm labourers led by George Loveless on a charge of illegally taking an oath. The accused were tried by a hostile court in Dorchester, were found guilty and given the harshest punishment of transportation to Australia.

News of their treatment filtered out around the country and the story acquired legs. A petition was organised. A demonstration involving 100,000 took place in London. In the end, the martyrs were pardoned and returned home in 1837. Perhaps unsurprisingly after the treatment they had received in their own country, most subsequently emigrated to Canada.

In 1937, the TUC built six memorial cottages, designed by Sir Raymond Unwin, to accommodate retired agricultural trade unionists in the village and these now contain a small museum. In 2000, the TUC commissioned a sculpture in Portland stone featuring George Loveless, which is displayed in front of the cottages.

28 Wareham

I always think of Wareham in my mind's eye as being slightly larger than it is, that sense of spaciousness being accentuated by the wide main street that runs north to south through the town. Wareham is also a place that doesn't seem to have changed much in my lifetime or indeed since the eighteenth and nineteenth centuries, when many distinguished buildings went up in the wake of a major fire in 1762.

Anglo-Saxon St Martin's Church in Wareham.

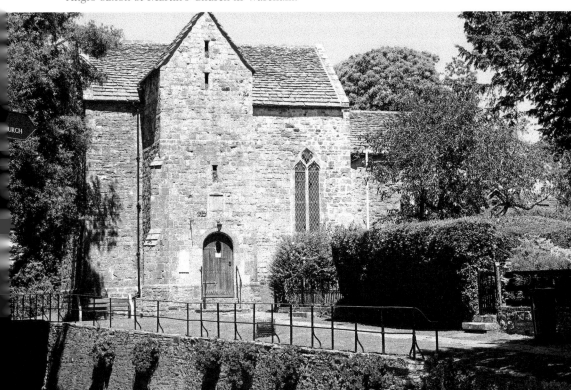

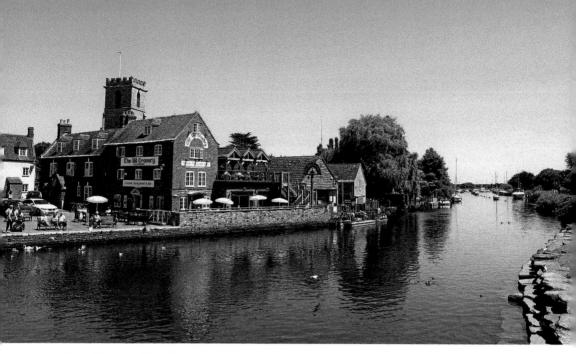

River Frome at Wareham.

The centre of the town is contained on three sides by the grassy defences around the outside dating from the time of King Alfred, which have largely kept at bay modern developments and shoved them to the north of the town beyond the railway station, which itself is a good walk from the town.

Look out for the Black Bear Hotel with its wonderful three-storey bow windows, the small and sometimes derided Town Hall on the crossroads dating from 1870, and the Red Lion and other eighteenth-century façades. Best of all is St Martin's Church with its saddleback roof, which is the only Saxon church in Dorset to have suffered no major alterations over the centuries. Inside is a marble effigy of T. E. Lawrence.

Wareham is cut off from the outside world by two rivers, though these being Dorset rivers that is not saying much. The aptly named River Piddle drains its tiny way to the north. The slightly larger, but still modest, Frome meanders its lazy course to the south.

This is my favourite part of Wareham with the two-sided square flanking the Frome by the bridge. It is a place to hang about and dream as the occasional yacht comes to visit or to take a trip on one of the small pleasure boats that run through the Frome's reedy banks. Imagine yourself back to the late ninth century when the Viking longboats landed here smashing up all opposition to their determined will.

Enjoy a pint and a pie in one of the pubs or, if you are rich enough, stay or dine at the adjacent Priory Hotel, built on the site of the old priory. It is a top destination for those with money and was a favourite with movie star Alec Guinness, who favoured the largest suite overlooking the tranquillity of the river where he always hoped he might spot a colourful kingfisher.

29 Corfe Castle

There has been much righteous anger at the destruction of ancient monuments in the Middle East in recent years. How could people do that, one wonders? Well, such destruction is not confined to far-off places. Here at Corfe, the castle was deliberately blown up in 1646, not in battle, but in the calm light of day because of Parliament's belief that it represented the powers of royalty and therefore had to go.

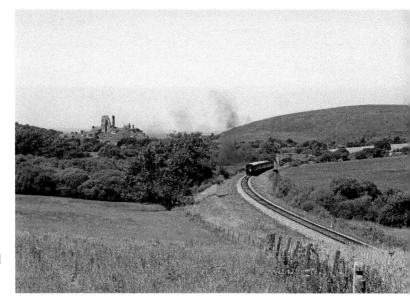

Corfe Castle, strategically placed in a gap in the Purbeck Ridge.

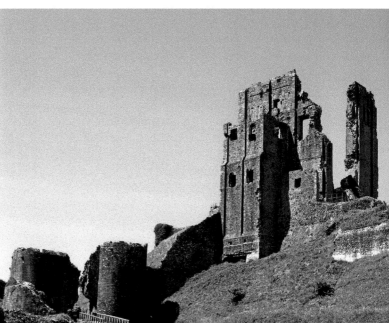

Corfe Castle.

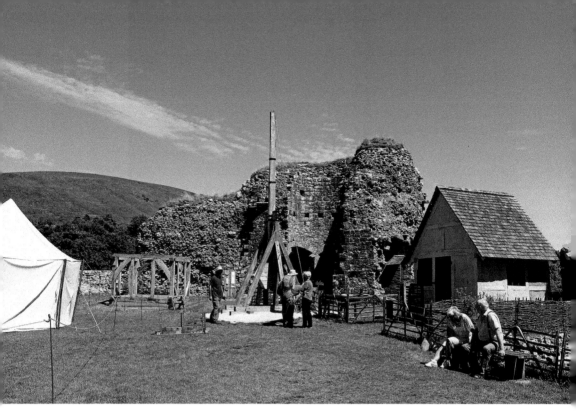

Reconstruction at Corfe of a trebuchet used to hurl unpleasant things.

Some sort of fortification is known to have existed on the site since Saxon times but what remains of the Corfe Castle we see today is a classic example of a Norman keep with additions in subsequent centuries. It is in a key strategic position right on top of its own hillock slap bang in the middle of the only gap in the long Purbeck Ridge.

The castle served as a fortress, a prison, a palace for kings and a family home over the centuries but saw conflict only during the Anarchy during the twelfth century when neighbour fought neighbour, and during the Civil War, which again pitched family against family.

In the latter, Lady Bankes held out with a tiny garrison for the Royalist cause with the castle under siege from Parliamentarians but, in the end, she was tricked into letting in what she thought were reinforcements who turned out to be for the Lord Protector and not the king. Whoops!

There is something rather awe-inspiring, magical and majestic about Corfe Castle. It may be a ruin but it has been one for such a long time. How much has happened in the world since it was built, since it was part blown up and on to today? It still dominates the landscape just as it has dominated the landscape here for ten centuries and that sort of puts us all a bit in our place really within our own finite window of time and within our own tiny bundles of fleeting cares.

East Dorset

30 Swanage

Swanage cast its eyes on Weymouth just down the coast in the late eighteenth and earlier nineteenth centuries and wondered if it too could transform itself into a fashionable seaside resort. At that time, it was a small fishing village with a nice beach that shipped out stone from the Purbeck quarries owned by John Mowlem, whose successors have taken their construction empire around the world.

It was Mowlem's nephew, George Burt, who really put Swanage on the seaside map in the late Victorian era. He built a new Town Hall, with a particularly grandiose façade taken from the old Mercers' Hall in London after its demolition, and in the following couple of decades was in the forefront of erecting numerous seaside boarding houses to encourage visitors to stay.

Every resort has a character of its own and if I wanted to choose a phrase to describe Swanage, it would have to include the word genteel. This was, and is, a resort favoured by the middle classes, or if not just the middle classes, then for

Swanage.

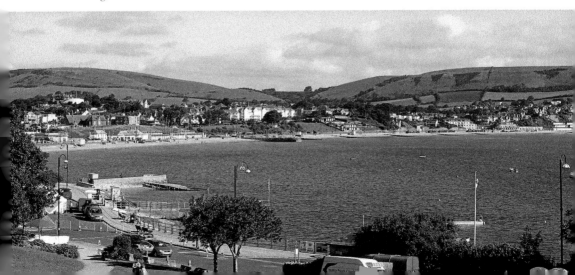

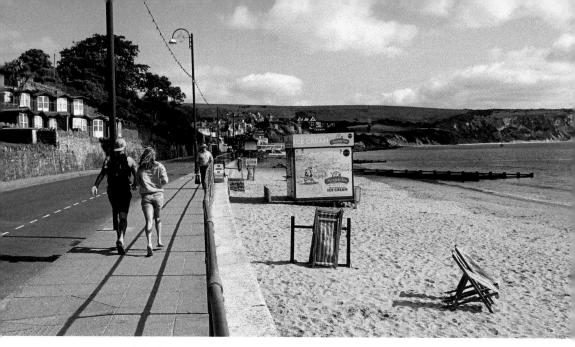

Swanage Beach looking towards the guest houses at the north of the town.

all those who liked, and like, to be beside the seaside but a seaside careful not to show too much frilly lace beneath its petticoats.

The children on the beach are having fun but in the sort of way that the *Famous Five* or the *Secret Seven* might have enjoyed themselves with lashings of ginger pop and plenty of jolly japes. This is not entirely surprising in that Enid Blyton discovered Swanage in 1931, fell in love with the town and kept putting bits of it and the surrounding Dorset countryside into her children's books. Her Kirriin Castle was based on Corfe. Whispering Island was Brownsea and PC Plod from the Noddy books was inspired by PC Chris Rone, the real-life police constable in Studland, who Enid thought walked around the village in a very stately way.

The old Grosvenor Hotel to the south of the pier where Enid often stayed has now gone but the Wellington Clock Tower, brought by Burt from London to Swanage in 1866 and erected in the hotel's grounds, is still there today. Is that Uncle Quentin I see striding along Peveril Point Road to view it?

31 Swanage Railway

The railway came to Swanage in 1885 branching off from the main London–Weymouth line at Wareham around 10 miles to the north and lasted until January 1972 when the axe fell. That summer it took just seven weeks to lift the track between Swanage and Corfe Castle and set about the process of selling off the land.

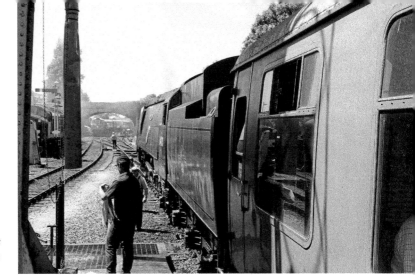

Battle of Britain class steam engine *Manston* prepares to leave Swanage.

Swanage railway station just as it was in the old days.

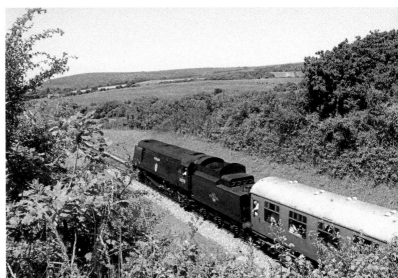

Manston hauls her carriages towards Corfe Castle.

However, never underestimate determined volunteers with a mission underpinned by an understanding of the practical realities of how to get things done and the ability to inspire confidence in those who may be able to provide the very substantial wherewithal to do it.

In 1976, a team of enthusiasts started laying track once again at Swanage. By 1979 they were able to run their first train a few hundred yards. It was not very far but enough to demonstrate the skill and determination and that perhaps this was a project that could have legs.

By 1988 steam trains were running to a newly built station at Harman's Cross. By 1995 the railway had reached Corfe Castle. The ultimate goal was finally achieved in the summer of 2017 with the introduction of a service once again linking Swanage with the main line at Wareham. It had taken more than forty years to do it but do it they have.

The round trip between Swanage and Norden is about an hour but you can get on and off along the way, not least at Corfe Castle, or just stay aboard to enjoy the views as the train puffs its way through the stunning Dorset scenery.

The platforms take you back to another era and what could be more fascinating to boys and girls of all ages – yes even those of you in your nineties – than to stand there gawping at the hissing wonder and majestic movements of a superbly polished steam engine. Even the diesels, which take some of the services, have a character of their own. Whatever sort of engine pulls your train, as you sit in the passenger coaches, you feel that you are travelling in a different style from today's normality of Network South East, First Group or whatever.

For those with an interest in food (and that includes me) there are also dining experiences on some trains ranging from Dorset cream teas, through curry nights to full meals. I'll have the French onion soup with cheese croutons, the slow-roasted lamb shank with cranberry jus followed by tiramisu gateau please. Yum-yum. I can hardly wait.

32 Durlston Country Park

Right on the south-east extremity of Dorset, Durlston is a little slice of paradise. The air is fresh from the sea. The cliffs descend straight down into deep water. The countryside is alive in summer with wild flowers, birds and butterflies. There are the remains of the quarries for Purbeck stone and Portland limestone, the Tilly Whim Caves and the measured mile for passing ships to clock their speed from the days before satellite navigation. Anvil Point Lighthouse is there warning ships of the dangers of the cliffs and above that are the footings of a Napoleonic telegraph station. Wander about and soak it all up. However your day started, it will end up better for a visit to Durlston.

It might not have turned out like this had history panned out in a different way. Victorian entrepreneur George Burt bought the land in 1862 with a view to building houses as part of his vision for extending Swanage to make it into a major seaside resort. Fortunately, the houses were never built and instead Burt turned the area into what he described as a 'New Elysian Landscape'.

As part of this he built a restaurant in the form of a mock castle in 1888 with stunning views out to sea and across to the Isle of Wight in the far distance. In keeping with the Victorian ideal of improving the masses, various geographical and other educational facts were inscribed on the walls and a giant 40-ton Portland stone globe was erected on the land below.

Inside the castle is not much to write home about and was described in 1905 by Treves as 'combining the architectural features of a refreshment buffet, a tram terminus and a Norman keep'. However, it is impressive from the outside and adds a sense of grandeur to the delightful surrounding natural landscape.

Right: Durlston Castle.

Below: Durlston Bay looking towards Peveril Point with Bournemouth in the far distance.

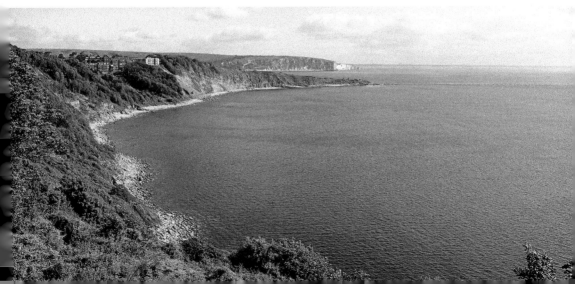

George Burt's Great Globe, rather theatrically placed with associated steps at Durlston.

33 East Dorset Coast

The Dorset coast is spectacular and well worth taking in from the sea. The only snag is the dearth of passenger boats running trips to view it. You can get a launch from Weymouth to take you round Portland Harbour but there is nothing on any regular basis sailing east past Lulworth Cove, St Albans Head and on to Swanage today.

However, there are trips from Poole to Swanage passing the Old Harry Rocks and Ballard Down and more intermittent ones also from Poole carrying on past Peveril Point towards St Alban's Head. These are a real gem.

The boats are seasonal and weather dependent but the trips are worth the effort if you can find one scheduled. Boarding at Poole Quay, you sail down the harbour past Lilliput, Brownsea Island, Sandbanks, which is said to have the highest property prices anywhere in the UK, and then on through the Swash Channel, with Studland to the south, on out to sea. Look over to the east and on a fine day you should be able to make out the Needles on the Isle of Wight.

The chalk cliffs at Handfast Point on the eastern extremity of Purbeck are over 100 feet tall and subject to constant erosion with Old Harry and his wife having parted company from the main cliff many years ago leaving a narrow gap called St Lucas Leap between them and the shore. The cliffs extend almost a mile further south to Ballard Point where Swanage Bay opens up with Swanage Pier on the southern side.

Some piers are big and blousy with fun and entertainment for all. Not so Swanage, which is a quiet wooden pier dating from 1896 and originally designed to accommodate the paddle steamers bringing the hordes of trippers in and out of Swanage several times a day up to the 1960s.

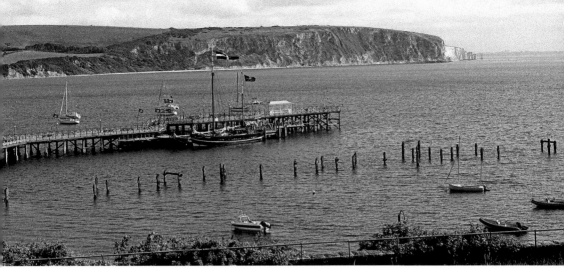

Swanage Pier with Ballard Point and Old Harry Rocks in the background.

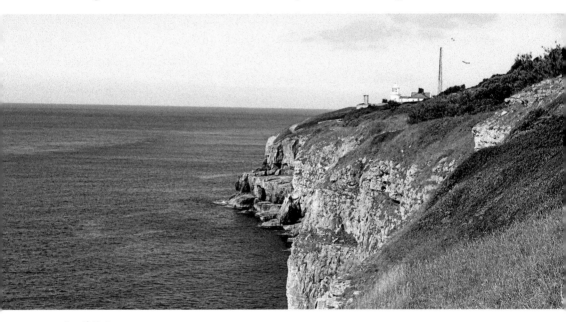

Anvil Point.

Beyond Peveril point the coastline goes up a notch passing Durlston Bay and Castle, Anvil Point with its lighthouse, the Tilly Whim Caves, former limestone quarries set into the cliff face, and Dancing Ledge.

St Alban's Head has a sense of remoteness about it with its little Norman chapel perched on top and has also been something of a graveyard for ships over the centuries before the advent of electronic navigational kit, which have given mariners so many useful tools to help keep themselves safe. As recently as 1962 I remember the large dredger *Sand Dart,* which was fitted with none of these modern wonders despite being nearly new, slamming straight into the rocks here at full speed in thick fog in March 1962.

34 Poole Quay

Poole Harbour is one of the largest natural harbours in the world. There is a narrow main channel that can accommodate ships with a draft of up to around 6 metres and a plethora of smaller boat channels, including one extending up to Wareham. Otherwise most of its huge area is very shallow with much of it drying out at low tide.

Poole has ever been an important port from the time of the Romans onwards and doubtless before that too. In the fifteenth century, it was a

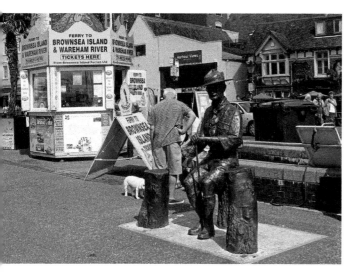

Left: Bronze sculpture of Lord Baden-Powell on Poole Quay.

Below: Poole Quay with the multimillion-pound super yachts beyond.

major exporter of wool and made itself rich in the seventeenth and eighteenth centuries with trade to North America and particularly Newfoundland. Today it is still a busy harbour for smaller commercial ships and ferries to the Channel Islands and France.

Poole Quay, which is now entirely devoted to the leisure market, always has a buzz about it with all the local passenger boats offering trips to Brownsea Island, Swanage, the Purbeck coast, Wareham or round the harbour.

On the other side are the giant super yachts built in Bolson's old coaster yard and when I say super yachts I mean big jobs costing tens of millions of pounds each. Who buys them? Who can afford them? Well, people do and looking at the numbers being built there must be quite a lot of people like that with the wherewithal to do it too.

There are plenty of pubs. Have some fish and chips or a carton of whelks. Enjoy the atmosphere or pop into Poole Pottery and watch the potters hand-painting a vase or plate of the sort you could buy and take home later as a more upmarket, but still affordable, souvenir of your day out.

35 Brownsea Island

Brownsea Island is owned by the National Trust and is accessed by boat from Poole Quay or Sandbanks. At just over a mile in length and only a little less than a mile in width, walking around the whole island is manageable for most and is a pure delight with the abundance of trees, flowers, wildlife (including the red squirrel) and birds.

Given its position at the entrance to Poole Harbour, the island was forever in the potential line of fire for attack. Henry VIII built a blockhouse here in 1547 as part of his string of coastal defences commissioned after he had fallen out with the pope over his marriage arrangements. In the Civil War, the island was garrisoned by Parliamentary troops.

After that there were various wealthy owners down the centuries including William 'Mad' Benson, who supplanted Christopher Wren as the government's surveyor of works; Sir Humphrey Sturt, who planted many trees in the eighteenth century; Colonel Waugh, who hoped to make a killing with the island's clay, but found that it was only suitable for bricks and drainpipes, in the nineteenth century; and the Van Raalte family in the Edwardian era, who liked entertaining their grand friends on a lavish scale. In 1927, Mrs Bonham-Christie bought the island, chucked all the estate workers off and lived as a virtual recluse with her female gym instructor, allowing the island to run wild until her death in 1961.

William Benson started the process of transforming the castle into a place to live. Most of the other buildings, including St Mary's Church and the houses for the estate workers, date from Colonel Waugh's time in the nineteenth century.

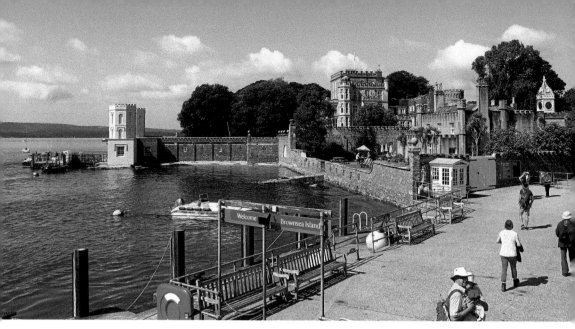

Welcome to Brownsea Island.

Brownsea Island holiday cottages.

Lord Baden-Powell, hero of the Boer War, persuaded Van Raalte to allow him to use Brownsea for his first ever boy's camp in 1907 and Scouts have been coming there ever since.

Brownsea Island is a perfect gem for a perfect day out. There is something magical about arriving on an island once owned by the seriously rich and accessed only by boat.

36 Bournemouth

There are those who don't like the idea that Bournemouth is in Dorset at all. They think that it is more properly in Hampshire where it always used to be until Prime Minister Edward Heath took out his green fountain pen and redrew the county boundaries in 1972.

In truth, it is unlike anywhere else in Dorset, forming a massive and expanding urban conurbation linking Poole in the west to Christchurch in the east and making it the most populace part of Dorset. Where the last century has seen only modest changes within the wider county, the landscape of Bournemouth itself has changed beyond all recognition.

In 1800, Bournemouth simply didn't exist. There was the beach, the cliffs and the heathland beyond but that was it, no houses, no town, no nothing. It was Lewis Tregonwell who started the ball rolling by building himself a home in 1810 near to where Bournemouth Pier is today. Others followed suit and the conglomerate started to grow.

After the railway made a belated arrival in 1871, having originally been routed to the north to miss the growing town altogether, the pot started to bubble and by the 1880s Bournemouth was being touted as a perfect holiday destination with the healing properties of its sea-fresh air making it most suitable for invalids. Among those who came for these curative cares was Robert Louis Stephenson, who wrote *Kidnapped* while staying in Alum Chine Road in the mid-1880s.

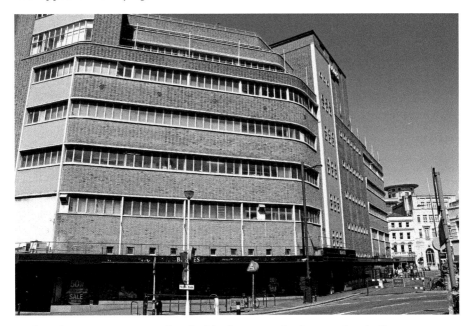

Beales's department store was bombed in the war and subsequently rebuilt.

Bournemouth Pleasure Gardens with the diminutive River Bourne.

As the town grew Weymouth man John Beale set up a department store bearing his name in 1881. He is credited as being one of the first anywhere to introduce a Father Christmas handing out gifts for the children to help boost his seasonal sales.

My favourite part of the town is the Pleasure Gardens, which thread their way by the side of the diminutive River Bourne and eventually open out onto the promenade and beach with its lovely views across to Swanage and the Isle of Wight. There is grass and flowers along the way, a bandstand, an aviary, crazy golf and in the cool of the evening colourful illuminations that make you feel that you are on holiday in an enchanted place.

Compared with many other seaside resorts that have struggled as their natural market of visitors have flown off to sunnier climes abroad, there is no sense of a fading past in Bournemouth. It is a vibrant town with a growing business background, and a state of the art conference centre.

Bournemouth appeals as a destination across the generations not only to those with blue rinses longing for a 'Knees up Mother Brown' experience but also to a mixed and younger crowd who have different aims and aspirations. Take a look at the surfers in their shiny wetsuits riding Bournemouth's usually rather modest wave crests before they clink the tops off their Peroni bottles and head off into town to take advantage of the booming night-time economy.

37 Russell-Cotes Art Gallery and Museum, Bournemouth

Have you ever wondered how you would spend limitless funds if ever you were seriously rich? I have. I would commission a replica of the paddle steamer *Consul* and set up an endowment fund so that she could sail in perpetuity between Weymouth and Lulworth Cove. Unfortunately, there is a snag in this exciting plan. Unlike Merton Russell-Cotes, I am not rich.

Merton knew about paddle steamers, watching their daily comings and goings in summer from Bournemouth Pier just outside his Royal Bath Hotel, but it was not on them that he spent his fortune. Instead he commissioned a substantial mansion, next door to his hotel, designed by John Frederick Fogerty to combine Italian Renaissance with old Scottish Baronial. He gave it with all his love to his wife Annie for her sixty-sixth birthday.

Merton and Annie Russel-Cotes first arrived in Bournemouth in 1876 when they bought the Bath Hotel, renamed it the Royal Bath Hotel and set about turning it into the best place to stay in town, attracting the richest and most famous of the day as guests. This was the source of their considerable and ever-expanding wealth.

The couple travelled the world extensively collecting as they went and furnishing their hotel with all their new treasures. These became so vast in numbers and diverse in range that the mansion next door became essential as an overflow to house them all.

Merton Russell-Cotes's mansion.

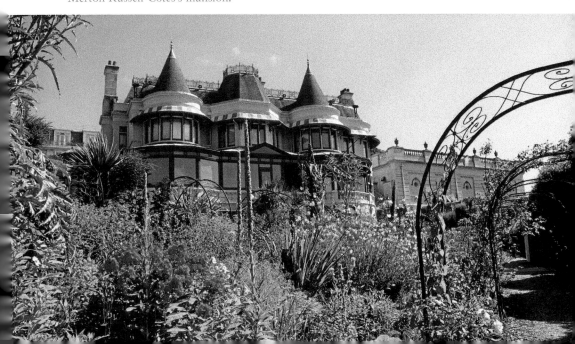

The couple were active in the town. Merton was mayor. They lived there until 1920/21 after which their house passed to Bournemouth Borough Council to become an art gallery and museum.

The Russell-Cotes Gallery is unlike any other provincial seaside property of which I am aware. The rooms have a fabulous fantasy feel, with original wallpaper, stained glass and Poole Pottery tiles. Are we in Scotland? Are we in Italy? Are we in Japan? There is a wondrous collection of paintings including Pre-Raphaelites, artefacts including Napoleon's dispatch bag, all things Japanese, plus props and costumes from Russell-Cotes actor friend Sir Henry Irving.

All in all, there are around 50,000 items either on display or in store. If you haven't been, there is only one thing to do: go and take a look.

38 Bournemouth Pier

By the middle of the nineteenth century people were starting to travel on a scale never seen before. The railways were being built and suddenly you could get from London to the seaside and back in a day, unheard of in previous generations.

The seaside, oh how wonderful that must have seemed to all those masses of people used to a life of close-packed, smoked-filled drudgery in the towns and cities. At the seaside there was fresh air, refreshing seawater and sparkling sunshine – well that wasn't guaranteed.

Bournemouth Pier with its tower for the zip wire to the beach.

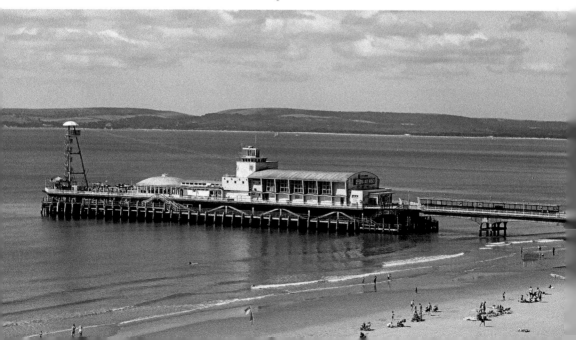

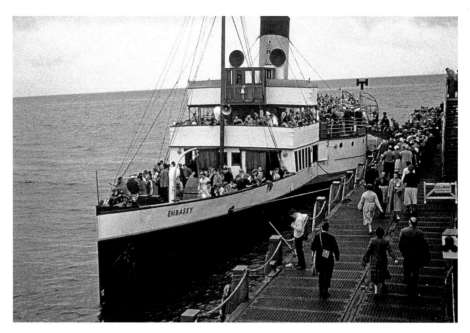

Paddle steamer *Embassy* loading at Bournemouth Pier in 1963.

These new visitors not only wanted to be by the seaside and be in the sea but also they wanted to be on it too. That required boats. That required a means of access and that meant piers. In the second half of the nineteenth century all the major seaside resorts around the country either built piers or wished they could. Some of the biggest like Brighton even had two.

The first one to go up at Bournemouth was a 100-foot wooden jetty in 1856. This was replaced five years later by one 1,000 feet long, which was subject to varying degrees of damage by winter gales over the years until replaced by an 838-foot iron pier in 1880 designed by the doyen of British pier designers, Eugenius Birch. This was extended to 1,000 feet in the 1890s and has been subject to various rebuilding programmes over the years, not least after the Second World War, and in 1960 when a new pier theatre was added.

In its heyday, Bournemouth Pier was served by a plethora of local and visiting paddle steamers each season. You could have climbed aboard and crossed the Channel to Cherbourg or the Channel Islands, sailed round the Isle of Wight calling at Sandown, Shanklin or Ventnor, cruised down the Dorset and Devon coasts to Weymouth, Torquay and Dartmouth, or just enjoyed local trips to Swanage, Lulworth Cove or Yarmouth, Isle of Wight.

Even as late as 1960 there were still three paddle steamers, *Monarch, Embassy* and *Consul*, regularly offering excursions from the pier but it was downhill all the way after that with the last of them, *Embassy*, making her final call in September 1966.

Since then smaller motor vessels have run local services but even they have gone now. Piping millions of tons of sand onto Bournemouth beach has reduced the depth of the water at the pier and in the winter of 2016/17 gales caused more damage to the landing stage, which has been closed to all traffic as a result.

However, the pier remains very much open for promenading and to take the sea-fresh air and now has the added advantage of a zip wire down which the brave and fearless can slide from a specially constructed tower to the beach. I am told that it has been a real hit for certain sorts of weddings where the bride and groom like to seal their tryst, holding hands in full bridal kit while hurtling along above the heads of their admiring guests. What larks, Pip. Oh, what larks.

39　Pavilion Theatre Bournemouth

Bournemouth may have been a late starter as a town and seaside resort but it was fast to catch up and attracted both residents and visitors with money to spend and aspirations to get what they wanted at a level higher than in some other resorts. For example, in 1893 a professional orchestra was founded and funded by the municipal borough under the leadership of Dan, later Sir Dan, Godfrey This expanded down the decades into what is now the internationally acclaimed Bournemouth Symphony Orchestra.

Pavilion Theatre, Bournemouth.

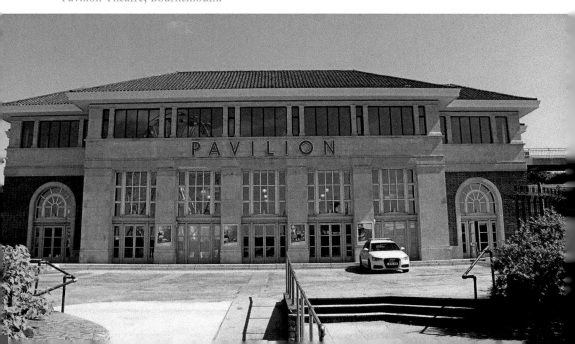

Pavilion Theatre foyer.

In 1929, the Pavilion Theatre was opened by the Duke of Gloucester not only to provide a new venue for the orchestra but also to stage quality plays, shows, opera and ballet.

The building is of red brick with Empire stone dressings under pantiled roofs and has undergone several improvements over the years including better sight lines from the circle, and enlarging the fly tower.

The entrance is spacious with stairs on either side curving up to the circle. The theatre itself has a feeling of opulence with the Grecian and Egyptian influence in its design then the fashionable form in the 1920s. Historic England claim that no other resort has such a complete and complex example of this style and period in a multi-entertainment venue.

It was in this theatre that I saw my first opera as a boy, a performance of Puccini's *Madam Butterfly* given by a touring Sadlers Wells. It just knocked me out. I had never heard such a sound or seen such a huge orchestra before. It was so big that it spilled over outside the orchestra pit with the harp on one side of the stage, the percussion on the other and the trombones and tuba wedged in by the front stalls. The late Roderick Brydon conducted, then at the start of a career that would take him on to the international stage conducting at many of the greatest opera houses in the world including spells as music director of the opera at Lucerne and Bern.

40 Tuckton Tea Garden Boats, Christchurch

Most of Christchurch Harbour is inaccessible from the land. You could drive through Christchurch and simply never see it.

Look at an Admiralty chart of the harbour and most of it is green, which means it dries out at low tide. The channels that have water are generally very shallow. So, how do you get to see Christchurch Harbour?

The answer to that is a small fleet of launches designed in the 1930s specifically for the task with a draft of less than 18 inches fully laden and their propellers protected in tunnels within their hulls to prevent them getting caught up on the bottom or in the weed. They are charming vintage boats with names like *Headland Belle, Headland Maid* and *Headland Queen* that offer the opportunity to sail down the River Stour from Tuckton Tea Gardens, first opened in 1903 by Mr William Nutter-Smith, to Mudeford Beach calling at Wick and Christchurch on the way.

Tuckton Tea Gardens.

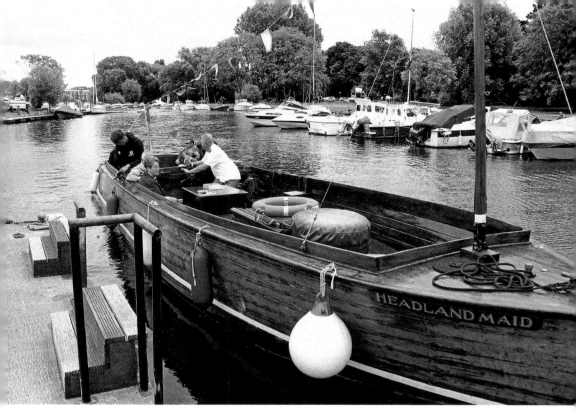

Skipper Mark Cox takes *Headland Maid* away from the Tuckton Tea Gardens.

The boats have the feel of taking you back in time to a gentler pre-war age and the river itself is much as it always was, although there are modern yachts along the way and some developments and houses on the Christchurch side including the Captain's Club Hotel on the site of the old Pontin's Holiday Camp. Christchurch Priory dominates the background.

Originating at Stourhead in Wiltshire, the River Stour wends its way through Sturminster Newton, Blandford and Wimborne before reaching Christchurch where it is joined by the even smaller River Avon (no not the Bristol Channel Avon), which both empty out into Christchurch Harbour before funnelling out to the sea through the very narrow Run at Mudeford.

North Dorset

41 Cerne Giant

Goodness, hasn't he got a big club? I wouldn't want to be on the receiving end of a whop from that. Who is he? Who cut this colossal 180-foot-high presence into the hillside at Cerne Abbas? Why did they do it and why is he holding such a massive weapon in his hand in such an aggressive fashion when the state of another part of his anatomy suggests that he has other things on his mind anyway?

To all this, the only honest answer is that nobody really knows. Some say that he represents a Saxon deity. Others are fond of the notion that he is a Roman interpretation of Hercules wielding his famed club. There are more still who believe that he represents an overtly rude caricature of the much-hated Oliver Cromwell, the divisive Lord Protector of the Civil War, but in that case why didn't the carvers add a few facial warts to give his diminutive head a real sense of authenticity to press their mocking point? Completing the job must also have taken a while to do, so it could hardly have been a clandestine carving out of sight of parliamentarian spies.

Among all this doubt, debate and speculation, there is just one certain fact. There is no record of the Cerne Giant in any known documents before the late seventeenth century, which suggests that he may be a lot younger than some people like to think. However, even this is not as straightforward as it seems. The fact that something isn't recorded doesn't necessarily mean that it isn't there. Perhaps nobody wrote it down or, if they did, maybe whatever they wrote it down on got lost.

With all this lack of certainty, the Cerne Giant is a fecund field for speculation with his priapic appendage lending credence towards the notion that he was intended as some sort of fertility symbol designed to help increase the birth rate at some point in history when the population needed expanding.

Who knows? For me though there is an even greater puzzle than this. The Victorians took a dim view of exhibitions of nakedness and indecorous behaviour. They tried to sanitise Shakespeare's plays for a family audience and had no scruples

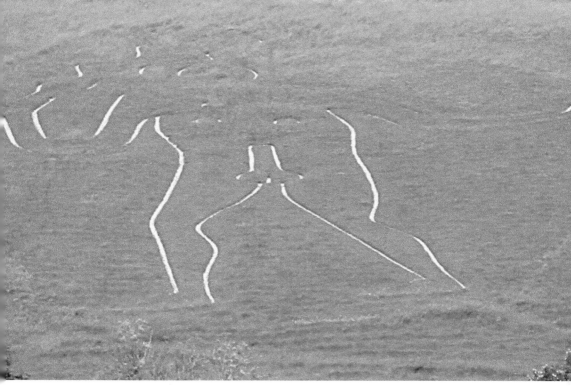

The Cerne Giant.

about taking a chisel to indiscreet bits and bobs, as they saw it, on nude statues. Given their prim desire to cover up anything that they found offensive, the real question for me is this: why didn't they dispatch a team of hillside hackers to the dark depths of Cerne Abbas to cut out a voluminous pair of pants for the giant?

42 Milton Abbas

At first glance, the picture-postcard perfect and simple white cottages under identical thatched roofs of Milton Abbas conjure up a dream of the rural idyll. Who would not be happy living here away from the stresses, strains, cares and troubles of a meaner spirited outside world? In fact, these cottages harbour a darker secret.

In the 1770s Joseph Damer, later Lord Milton and 1st Earl of Dorchester, decided that the local bumpkins of this village lived too close to his proposed new mansion and the abbey. They were a nuisance to him there so he decided unilaterally to demolish their homes and replace them with the then country house fashionable accessory of a lake. So, it was everybody out with husbands, wives, children, grandparents, uncles, aunts, nieces and nephews all driven away from their homes with many left to fend for themselves as best they could.

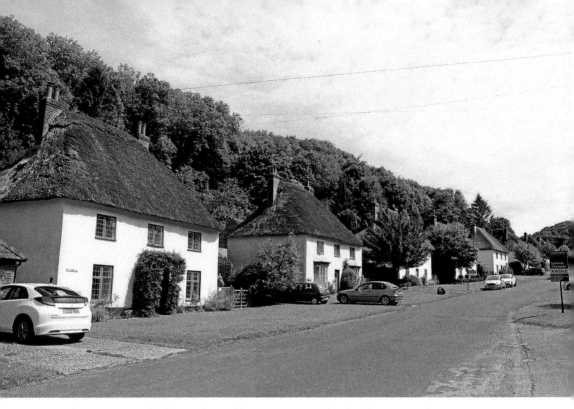

Above: Cottages built at Milton Abbas to accommodate local estate workers.

Below: Milton Abbey School next to Milton Abbey at Milton Abbas.

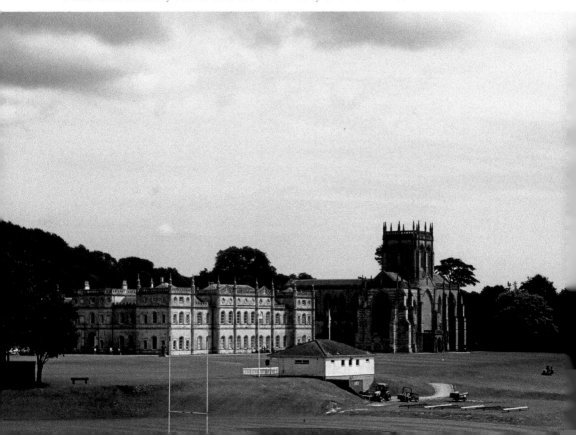

Some, including the most essential workers for the estate, were rehoused in the new cottages built around 1780 half a mile away from and out of sight of Damer's nice new mansion. Not so bad, you may think, looking at the cottages today, but remember that when they went up each was designed to take two families and thereby accommodate up to sixteen.

The abbey was founded by King Ælthelstan in the tenth century but most of the present church dates from the fourteenth and fifteenth centuries with further additions in Victorian times.

The mansion next door was designed by Sir William Chambers for Damer and was completed in 1774 as part of his restructuring of the whole area. It is built round four sides of a quadrangle, is in the Gothic style and is now Milton Abbey School. The grounds, including the lake, were landscaped by Capability Brown.

43 Blandford Forum

Blandford Forum is one of the most satisfying Georgian towns anywhere in England according to Pevsner. There is good reason for this assessment too. In 1731, the town caught fire with three quarters of it being destroyed, so it was rebuilt in a unified style under the influence of local worthies and surveyors

Gateway to Bryanston.

Above: The picturesque River Stour from Blandford Bridge.

Below: Blandford's Church of St Peter and St Paul.

William and John Bastard. Stand in the middle of the market square and look through all points of the compass. Try to ignore the passing traffic and see what a fine job they made of it.

In the centre on the north side is the Town Hall looking suitably impressive with its three-bay façade with an arcade behind Romanesque arches on the ground floor, three pedimented windows on the first floor, and a triangular and dentilled pediment with ornate urns on top. On the south side are the Red Lion and the Bastard's own house, which have carriage entrances, massive pilasters and wondrous detail. Just look at the rusticated surrounds of the first-floor windows and the differing triangular pediments above.

Back on the north side is the little monument, built between 1733 and 1739, dedicated to the fire by the side of the Church of St Peter and St Paul. The church has a large tower at the western end topped by a cupola and an entrance surrounded by substantial Doric pilasters. The inside is also impressive with large Portland stone columns.

Walk on along West Street and you come to the bridge over the River Stour with the water meadows on one bank and the cliff on the other. You can drive in through the 1778 gateway to Bryanston, passing the school, in a building by Norman Shaw of the 1890s, and come out at the other end north of Blandford.

44 Kingston Lacy

There are many manor and country houses tucked away throughout Dorset as a legacy of onetime wealth. None are quite so grand as Kingston Lacy, home for four centuries to the Bankes family who also owned, and lived in, Corfe Castle before it was demolished by Parliament in the Civil War.

This new house was designed by Sir Roger Pratt, completed in 1665 and marked a change in how such grand houses should look. This is not a mock castle designed for living and entertaining like Lulworth. It is a house and looks like a house rather than a house that looks like a fortress.

However, what we see today is quite different from Pratt's original brickwork exterior as the mansion was completely remodelled between 1835 and 1846. Caen stone with Portland stone dressing was brought in to reface the building. The ground was lowered. Much other detail was added including chimney stacks and rusticated quoins.

All this was commissioned by William Bankes, a friend of Byron, and a lover of the excesses of life and art. He travelled extensively sending back home an Italian marble staircase, as well as all manner of other fixtures and fittings, artefacts and art. As a result, Kingston Lacy has rather the feel about it of an Italian palazzo rather than a draughty old Dorset country house.

Above: Kingston Lacy House.

Below: Marble staircase at Kingston Lacy.

Room with a view from the east side of Kingston Lacey.

Unfortunately, William's excesses extended to being caught in embarrassing circumstances in rather too intimate an embrace with a young guardsman after which he fled abroad and lived for the rest of his life in Italy. That did not stop him continuing to take an interest in Kingston Lacy and sending back home a stream of treasures. As a result, the house is a gem with its fine collections including paintings by Rubens, Van Dyke, Titian and Brueghel.

45 Sturminster Newton

Sturminster Newton likes to think of itself as the capital of Dorset's Blackmore Vale. It is the birthplace of poet, schoolmaster and champion of the Dorset dialect William Barnes, who arrived in this world in 1801.

It is the town to which Thomas Hardy brought his bride of two years Emma in 1876 and where he wrote *The Return of the Native*. The pair took a house at Riverside Villas overlooking the Stour not far from the bridge and spent two of their happiest years together there. Sturminster Newton was sufficiently close to the Dorset Hardy loved and was at the core of his inner being but was sufficiently

Above: Sturminster Newton Mill.

Below: Sturminster Newton's seventeenth-century bridge.

far away from his mother and the family home at Bockhampton just outside Dorchester. Complex indeed are the emotions of the rising star.

Not far from the bridge is the mill, which dates from the seventeenth and eighteenth centuries, although there is thought to have been a mill on the site as early as Saxon times. It still functions today as a mill, although it is not always open. You can see the corn being ground, which is an impressive sight if you hit the time right, and you can buy a bag of the resulting flour. Sadly, there is no waterwheel powering the mechanism today. The last pair of wheels, which were put in around the middle of the nineteenth century, were removed and replaced by a water turbine in 1904.

Hardy had a view of the river from his villa and wrote the poem 'On Sturminster Footbridge', which captured the sounds as 'the current clucks smartly into each hollow place' and ended 'beneath the roof is she who in the dark world shows, As lattice-gleam when midnight moans.' Ah, the pleasures of youth.

46 Sherborne

Sherborne is a town that seems to me to be absolutely at peace with itself. The abundance of Ham Hill stone throughout lends an aura uniting the whole. There is the feel that we might be in a small university or cathedral town.

Sherborne Abbey.

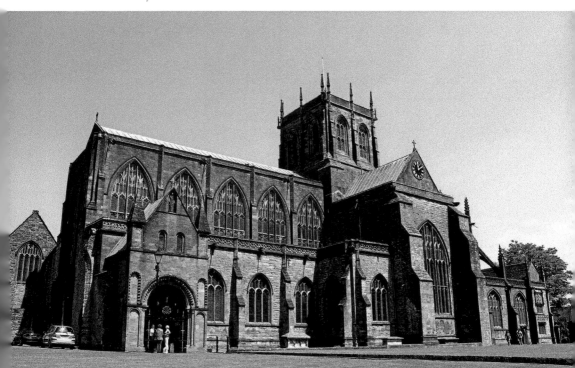

St John's Almshouses, Sherborne.

Sherborne is neither of these but the presence of the distinguished Sherborne School lends a hinterland of academic excellence and the abbey could well be a small cathedral. In fact, Sherborne was the seat of the Bishop of Wessex from 705 AD to 1075 when the see upped sticks first to Old Sarum and later to Salisbury.

The abbey is the jewel in the crown. Small parts of the original Saxon church remain but most of what we see today dates from the late fourteenth, fifteenth and sixteenth centuries with other additions and modifications from later years. Most spectacular of all is the stunning fan vaulting that combines such mathematical precision with perfect beauty.

Music is also in the air at Sherborne with the school having a strong music department, which has spawned much else including what is now called Dorset Opera. In 1974, music masters Patrick Shelley and Robert Glen assisted by Jennifer Coultas put on a performance of Smetna's *The Bartered Bride* with professional soloists and orchestra, an amateur chorus and locals doing the scene shifting and other backstage work. It was a triumph that led to annual productions following year on year right up to the present with Gounod's *Faust* and Rossini's *Count Ory* being staged at the Coade Theatre at Bryanston in 2017.

For any who have not yet found the key to the door into opera then I urge you to try it. Opera is not just about canaries warbling stratospheric fireworks,

although it can be that. At its best, and my greater gods are Handel, Verdi and Britten, it is so much more.

47 Sherborne Castle

In the late sixteenth and early seventeenth centuries, relations between Britain and Spain remained fractious, with several adventurous English mariners being charged by Elizabeth I to harry the Spaniards at sea and plunder their valuable cargoes, particularly if they were loaded with silver and gold.

They did a good job. Although many are forgotten today, some, like Sir Walter Raleigh, have passed into legend, immortalised as great heroes rather than as the pirates that they were if looked at through the other end of the telescope.

Like his most successful contemporaries, Raleigh became seriously rich on the proceeds of his nautical adventures and put some of his money into building the new Sherborne Castle in 1594. It is of a rectangular shape to which hexagonal corner turrets were subsequently added.

Sherborne Castle.

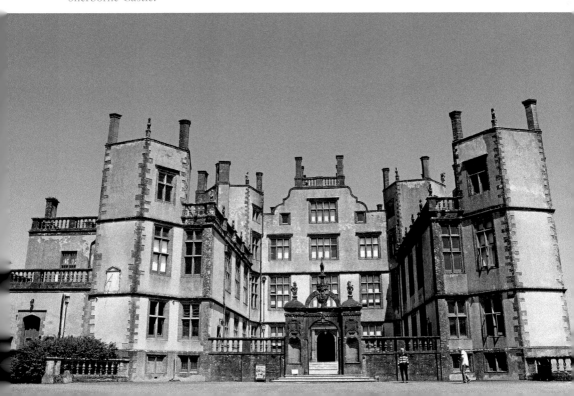

Inevitably such a life lived on the edge of a sword had its troubles as well as its successes and Raleigh for a time fell out with Elizabeth I and was imprisoned. In the end, he had his head chopped off by her successor James I in 1618.

After that, Sherborne Castle was bought by the Digby family and has remained in their ownership ever since. In the eighteenth century Capability Brown was engaged to landscape the extensive grounds and pleasure gardens with rolling lawns, sweeping vistas and majestic trees, including a serpentine lake, an orangery and a Gothic-style dairy. Inside the castle, along with Raleigh's Tudor kitchen, there are stunning collections of paintings, porcelain, furniture and other artefacts acquired by the family over the centuries.

48 Fontmell Magna

Fontmell Magna is one of those pretty little Dorset villages that you feel you must visit not only because it has a charm of its own but also because of its name. Other places similarly immortalised by John Betjeman in his poem *Dorset*, with their endless whist drives in institute, legion and social clubs, include Ryme Intrinsica, Sturminster Newton and Melbury Bubb. Go on, make sure you tick them all off on your list.

Set between streams and meadows on one side and chalk downland on the other Fontmell Magna is a mixture of thatched cottages and larger Victorian and

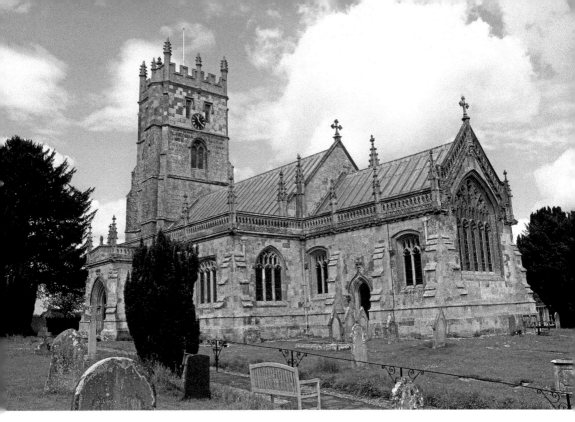

Above: The Church of St Andrew in Fontmell Magna.

Below: Springhead in Fontmell Magna.

Edwardian villas. The Church of St Andrew, which mostly dates from a rebuild around 1862, has a particularly interesting parapet of quatrefoils that runs all the way round.

Just up the road is Springhead, a pair of thatched cottages attached to a mill dating from the late eighteenth and early nineteenth centuries. When the mill closed in 1881 the buildings found a new use, first as a small factory for the manufacture of bottle tops and later cheese before being turned into a private residence in 1911.

Rolf Gardiner bought Springhead in 1933 and used it as a base to promote his ideas of ecological conservation and organic farming, which led to the foundation of the Soil Association. This work continues today with Springhead being a centre for creative and sustainable living. Gardiner was much influenced by his friend D. H. Lawrence and it is thought that he in turn influenced Lawrence on man's relationship with the natural environment.

Gardiner's son is Sir John Eliot Gardiner, who remains a local resident and farmer when home from practicing his other and most distinguished career as one of Britain's most international conductors.

Another local boy who made his mark in the wider world is Philip Salkfield, son of the rector, who was awarded a VC in the Indian Mutiny of 1857 during the siege of Delhi.

49 Shaftesbury

Everybody must surely know of Gold Hill, Shaftesbury. How many calendars, how many chocolate box wrappers, how many greetings cards have featured this photogenic climb in spring, in summer, in autumn and, yes, in winter too? For those who have missed this treat in print then you may instead have seen it on the screen, not least in the famous Hovis television advertisement with a boy and his bicycle larded from on high with the comforting and nostalgic balm of a smoothly sweet brass band.

Catch it on the wrong day or maybe in the wrong light and it may not seem quite as spectacular as the illusion and hype has suggested with the row of modest stone cottages steeply shelving away on one side and the buttressed retaining wall of the old abbey on the other. Indeed, there is something about Shaftesbury as a town that, while still thriving today, is not as thriving as it once was or, as Thomas Hardy put it, Shaftesbury throws 'the visitor even against his will into a pensive melancholy'.

This hilltop town 700 feet above sea level and sometimes up in the clouds when they are flying low was once the busiest centre in Dorset. It was the site

Above: Gold Hill, Shaftesbury.

Below: Ruins of Shaftesbury Abbey looking towards the altar.

of a burgh created by King Alfred. The abbey contained the richest nunnery in England. There were twelve medieval churches, no less than four market crosses and a castle.

Today there is much less but still enough to make a visit worthwhile. After taking a look at Gold Hill, check out the abbey ruins and the museum with its interesting collections including those on local button and lace making. Have a look in St Peter's Church with its magnificent porch vaulting. For those who love Hardy, try and find Ox House, which is the location he chose in his mind's eye for the home to which Mr Phillotson, the schoolmaster, took his new young bride Sue in *Jude The Obscure*.

50 Dorset Railways

Somehow travelling on a service train seems less of an excitement than a preserved railway even though the scenery may be just as good or even better. Many passengers sit immersed in their iPhones, tablets and laptops rather than catching the glories speeding by. Of course, if you are doing the same journey

Yetminster station on the line between Dorchester West and Yeovil.

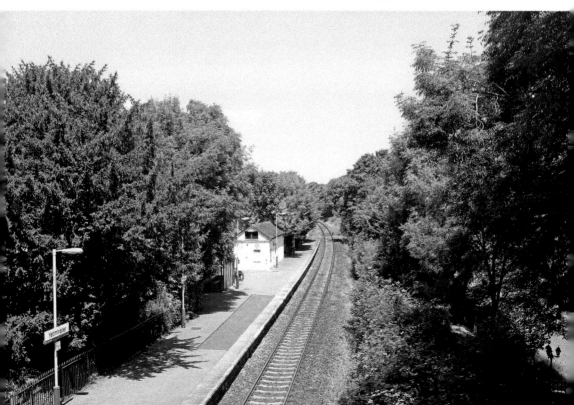

every day then you may get sick of the regular views but, nonetheless, we should not lose sight of the fact that the two main railway lines in Dorset give stunning access to the county.

The line from Poole to Weymouth passes Holes Bay, the western end of Poole Harbour and on to Wareham. We continue alongside the water meadows onto which the normally placid River Frome can burst its banks in rainy weather before we come to Wool. From there onwards to Dorchester South we cross heathland immortalised by Hardy and see the later nuclear complex at Winfrith. Turning south the railway then burrows through the Ridgeway tunnel spinning down the steep incline to Weymouth town and the sea.

Making north through Dorchester West, the line follows the River Frome to Maiden Newton and on via Chetnole, Yetminster and Thornford, all request stops, to Yeovil. If you have ever wanted to flag down a train and make it stop for you then this is your chance.

The downside is that the GWR trains on this route are pretty much bottom of the range and usually only have two carriages. The upside is the scenery. If you are not so good on your pins or don't have the time for walking then this is the way to see parts of Dorset otherwise difficult to reach from the comfort, well sort of comfort, of a railway carriage seat. Enjoy.

About the Author

John Megoran grew up in Weymouth and was educated at Weymouth Grammar and King's College London University, where he read chemistry, and the Guidlhall School of Music and Drama. He returned the coal-fired paddle steamer *Kingswear Castle* to service in 1985 and spent nearly thirty years running the business as well as sailing as the steamer's captain. John Megoran is a Freeman of the City of London, a fellow of the Royal Society of Arts and a trustee of the Maritime Heritage Trust.

Other books by the author published by Amberley:
British Paddle Steamers: The Heyday of Excursions and Day Trips
Weymouth and Portland in 50 Buildings
PS Kingswear Castle: A Personal Tribute
British Paddle Steamers: The Twilight Years